FEDERICO ZERI (Rome, 1921-1998), eminent art historian and critic, was vice-president of the National Council for Cultural and Environmental Treasures from 1993. Member of the Académie des Beaux-Arts in Paris, he was decorated with the Legion of Honor by the French government. Author of numerous artistic and literary publications; among the most well-known: *Pittura e controriforma*, the Catalogue of Italian Painters in the Metropolitan Museum of New York and the Walters Gallery of Baltimora, and the book *Confesso che ho sbagliato*.

Work edited by FEDERICO ZERI

Text
based on the interviews between
FEDERICO ZERI and MARCO DOLCETTA

This edition is published for North America in 1999 by NDE Publishing*

Chief Editor of 1999 English Language Edition
ELENA MAZOUR (*NDE Publishing**)

English Translation
TONINO SOFIA FOR QUALITALIA

Realisation
CONFUSIONE S.R.L., ROME

Editing
ISABELLA POMPEI

Desktop Publishing
SIMONA FERRI, KATHARINA GASTERSTADT

ISBN 1-55321-009-3

Illustration references

Alinari archives: 14t.

Giraudon/Alinari archives: 1, 2-3, 4b, 5, 6t, 6-7, 8, 8-9, 10, 10-11, 12-13, 13t, 27, 30, 33, 37, 39, 41r, 42b, 45/IV-XI.

Luisa Ricciarini Agency: 25.

RCS Libri Archives: 2t, 6b, 13b, 14b, 15, 16b, 18b, 20t, 21, 22t-b, 22-23, 24, 28, 29, 32t, 34t, 36t-b, 38t-b, 41l, 44/III-VII-VIII-XI, 45/IX-XII.

R.D.: 2b, 4t, 16t, 17, 18t, 18-19t, 20b, 26, 28, 31t-b, 32b, 34, 35b, 40t-b, 42t, 43t-b, 44/I-II-V-VI-IX-X-XII, 45/I-II-III-V-VI-VII-VIII-X-XII-XIV, 47.

Printed and bound by Poligrafici Calderara S.p.A., Bologna, Italy

* *a registred business style of NDE Canada Corp.*
 18-30 Wertheim Court, Richmond Hill, Ontario
 L4B 1B9 Canada, tel. (905) 731-12 88

The captions of the paintings contained in this volume include, beyond just the title of the work, the dating and location. In the cases where this data is missing, we are dealing with works of uncertain dating, or whose current whereabouts are not known. The titles of the works of the artist to whom this volume is dedicated are in blue and those of other artists are in red.

CHAGALL
THE FALLING ANGEL

Supported by a deep ironical touch, Chagall places even the most serious issues in an gentle atmosphere and unsettles each element of the representation beginning from the range of colors used. The con-

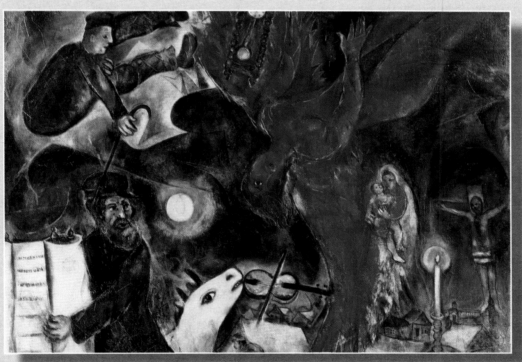

trasting colors of THE FALLING ANGEL highlight the sad tale of the dark years of war and give voice to the artist's conflicting emotions, torn as he is between hope and despair.

ODYSSEY OF A PAINTER

THE FALLING ANGEL

1923-1947

● Basel, Kunstmuseum, (Oil on canvas 148 x 189 cm)

● Marc Chagall was born on July 7, 1887 in the Russian town of Vitebsk, the eldest of the nine children of a poor Jewish family. His parents encouraged the boy's passion for painting and in 1906 Marc became the pupil of Jehoda Pen, a painter of the school of epic realism. A year later Chagall moved to St. Petersburg and for a short period attended the school of the Imperial Society for Fine Arts.

● The artist soon discovered he could not stand academism. After attending the study of the Russian painter Leon Bakst (1866-1924), in 1910, at the age of 23, Chagall moved to faraway Paris. In this capital of art, he came in touch with the avantgarde and Cubism whose principles he studied preferring the more lyrical touch of Robert Delaunay (1855 - 1941). Chagall also made another fundamental discovery: the joyous intense colours of Matisse (1869 - 1954) and of the *fauves*.

● While Chagall was on a short visit to Russia, World War I broke out: the artist was trapped in his home country. For eight years he held important public offices and organized with enthusiasm the Vitebsk School of Arts – later to become the Suprematist Academy.

● After a period of hard work and journeys to Palestine, France, Italy, Holland and Poland, in 1939 Chagall settled in France with his wife Bella Rosenfeld (married in 1915) and his daughter, Ida. His peaceful life was however soon disrupted by racist policies and in 1941 Chagall was forced to seek shelter in New York. Bella's death in 1944 interrupted Chagall's creativity for ten months.

● Back in France, the artist settled in Saint-Paul de-Vence where he married Valentina Brodskij and where he lived for the rest of his long, prolific days until his death on March 28, 1985 at the age of 96.

● Chagall's wanderings provide a background to his unique, personal style which reprocesses stimuli but is never radically altered by them. Reality is transfigured and enveloped in a poetic and religious atmosphere.

Marc Chagall

◆ SELF-PORTRAIT
(1914 Philadelphia, Philadelphia Museum of Art).
Light and shadows play on the young artist's face (Chagall at the time was 17) reflecting inner hopes and fears.
Chagall was born in a Jewish family when times were hard for the Jewish community in Russia. He thus developed a feeling of devotion and belonging to whatever represented his threatened world: religious and family traditions, childhood . Chagall created his own personal language with people and things: with it, in works as the *Falling Angel*, he tells an ancient story still alive in the heart of the artist and of the onlooker.

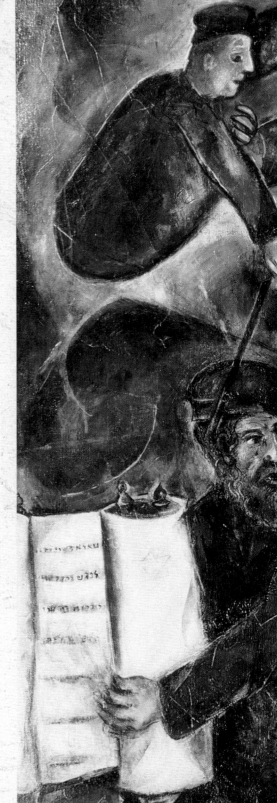

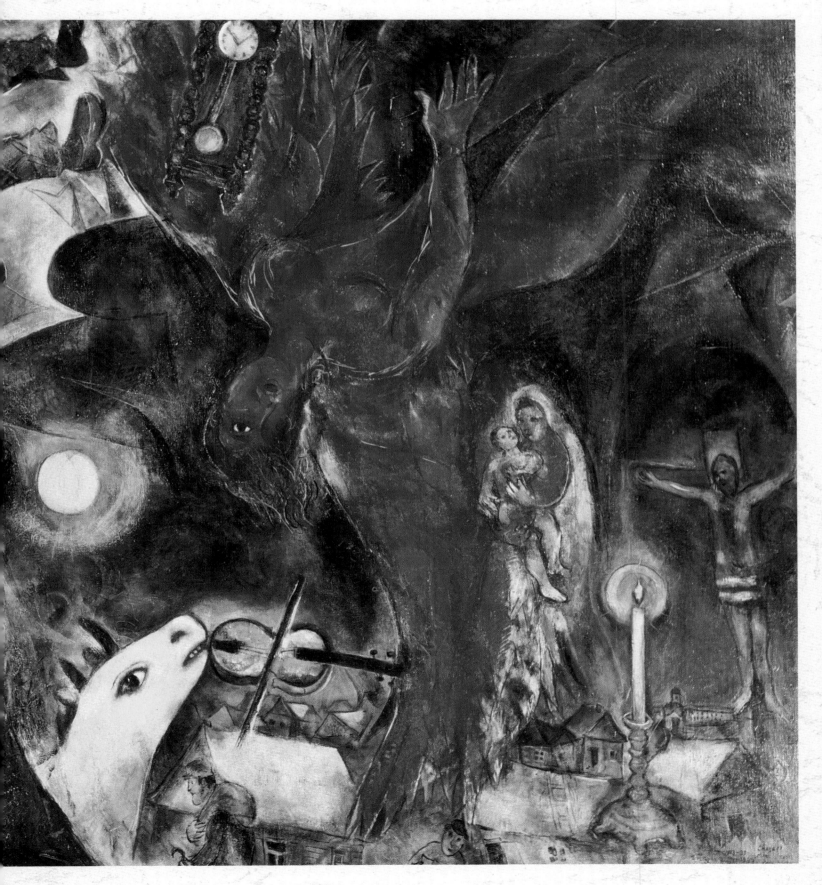

A CIPHERED DIARY

A black sky and a timeless atmosphere, envelop the figure of an angel with long brilliant red wings but no longer able to fly: the disastrous fall tears down an ancient world of certainties no longer secure. A pendulum clock gone crazy accompanies the descent. For Chagall the angel personifies naive imagination which once was a shelter, a way out.

● Next to the angel a man with a soft-green face and a walking stick floats in the dark, thick air. Beneath him a rabbi looks beyond the yellow cow while a musician-less violin settles as if a cloud on the roofs of a gloomy ghost city. The Virgin and her Child which seems to rise to the upper part of the picture are separated from Christ, still alive on the cross, by the immobile light of a candle.

● A whole world is condensed on this canvas to which, as to some kind of ciphered diary, the artist has confessed his inner life, his hopes, and the drama of the society he lives in. Completed over a long period time, in this painting one meets symbols and characters which seem to gather from afar to settle each in a pre-destined corner.

● Every image seems to spring up from the deep and meticulous processing of experiences: only after long and painstaking efforts the artist can manifest them on the sensitive, receptive surface of the painting. Chagall stated "one should not start with symbols but get to them".

● Thus, through these symbolic images, Chagall's painting simultaneously interprets various moments of reality, even if far from each other in time, summoning them back on stage through the extraordinary power of painting. There are never fanciful abstractions in Chagall's painting. All is strongly related to the artist's surroundings which he permeates with a religious confidence in a primitive, intact, world, free from the strict barriers of reason.

● In the *Falling Angel* the artist is telling, and fixing on canvas, the story of a long period of his life. Twenty-five years of direct, personal involvement in a sad, cruel age dominated by the brutality of war and by hate.

◆ TO MY WIFE
(1944, Paris, Musee National D'Art Moderne)
The Sky's deep blue swaddles the world of feelings as if trying to protect and keep it intact, far from reality. In this painting dedicated to Chagall's wife, colors spring vigorously forth and seem to give a voice to the characters, to the portrait of the artist and Bella, to the red angel who will meet defeat in the *Falling Angel* but here still spreads his long wings.

◆ THE FALL
The expression of terror and fear on the angel's face is enhanced by the desperate groping of his hands, vainly seeking support. Spread across the black sky the red wings seem tongues of fire. It is an intense image which the pendulum clock, linking as it does the angel's fall to the real world, makes even more effective. Mother and Child rise and offer hope.

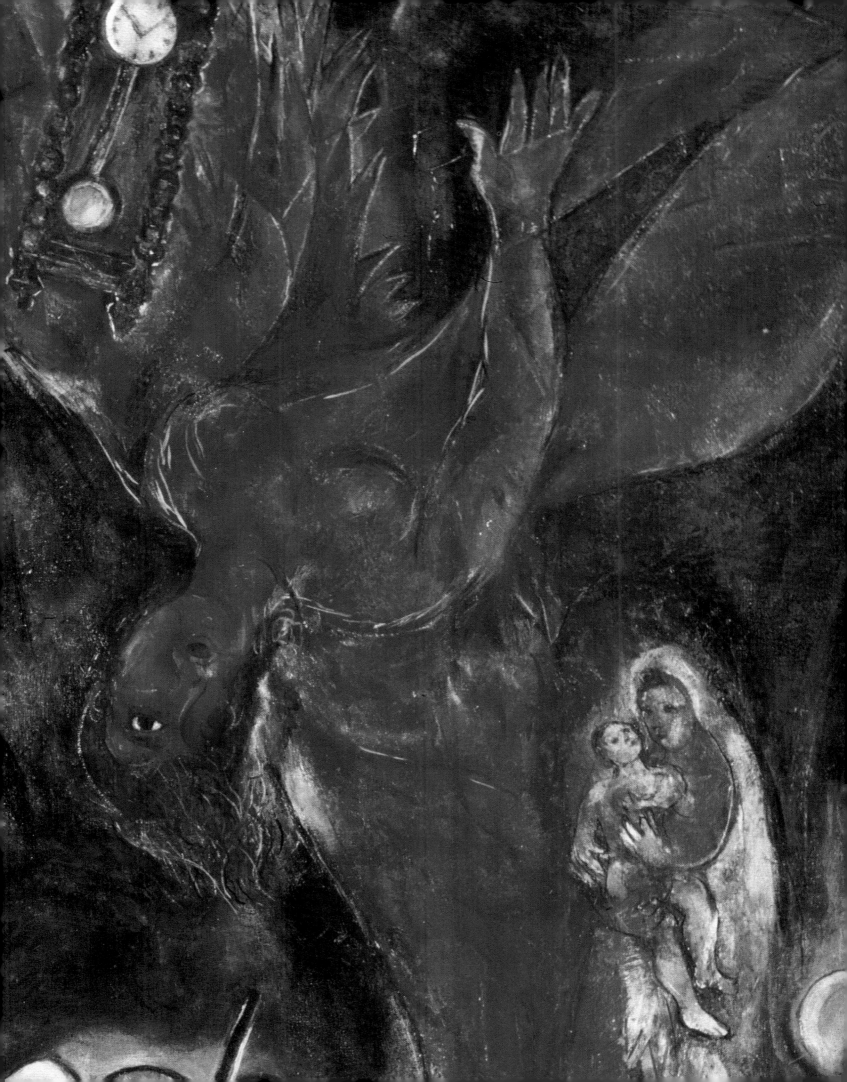

UNIVERSAL ALLEGORIES

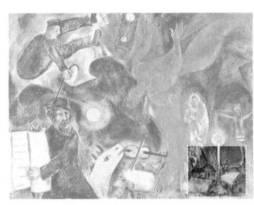

In this painting the artist summarizes with crude lyricism the odyssey of his own soul represented as a universal allegory. Chagall began this work in 1923 once back in Paris. Revolutionary hopes in Russia had been shattered: the falling angel could well refer to real historical events. The long genesis of the painting led to a settling down of the images: at the beginning they were limited to the sole characters of the Jew and the angel. Time added new icons to the initial idea: the artist slowly creates a fresco mixing Jewish tradition, personal life and Christian hope for redemption.

● The painting was completed in 1947 just before the artist's final return to France. At the time Chagall was living in New York where he had sought shelter in 1941, arriving there on the very day German troops invaded Russia.

● Following the success of his set designs for the opera *Aleko* in Mexico, Chagall created the designs and costumes for Stravinsky's *Firebird* at the New York Ballet Theatre. The bird on fire motif will appear again in the great useless wings of the falling angel.

● The painting represents the end of a long period in Chagall's life, which he summarizes in images inspired by sorrow and illuminated by a slight glimpse of hope. This was the end of the wanderings which Chagall, a French citizen since 1937, had started due to enforcement of racist laws. This period had been interpreted and inaugurated in 1937 by the painting *Revolution*. The artist himself destroyed this work in a moment of despair, frustrated because he had been unable to create a universal allegory from his personal history and that of his age, something he would finally achieve with the *Falling Angel*.

◆ **THE TASTE OF MEMORIES**
In a corner of this painting the dramatic atmosphere softens, leaving more room to the image of Vitebsk with its steep roofs and closed windows. The memory of his native town often creeps into Chagall's paintings as in *Windows, Vitebsk* (1908, St. Petersburg Gordoeva collection, below). In his biography the painter recalls "My town, sad and gay! When a child, I looked at you from our childish doorstep. You were clear to infant eyes".

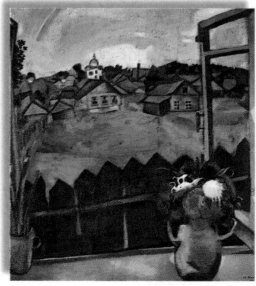

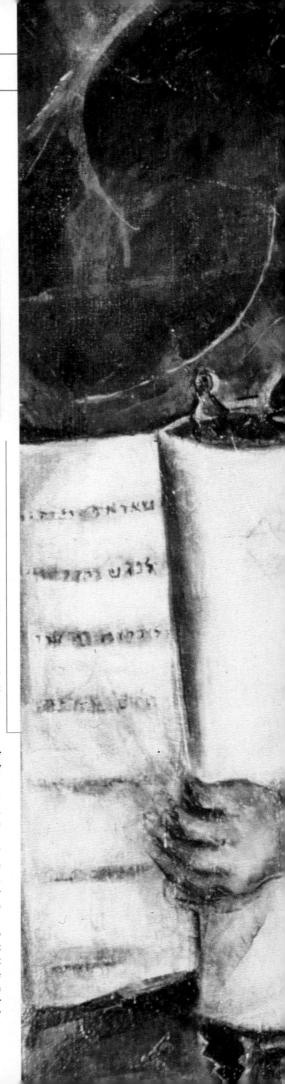

ART MOLDED BY MEMORIES

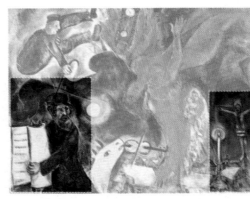

The lively imagination of Marc Chagall is populated by a set of colored characters each full of meaning distilled from History and personal experience.

● Born of the artist's deep spirituality and faith which shed light even on the bleakest reality, this synthesis is the strength and grandeur of a painter ever searching for a universal visible formula.

● The "*âme simple*", the painter's "simple soul" manifests through symbolic images which embody a story, a love, a dream or a deep desire. In the *Falling Angel* many of the characters and objects Chagall was fond of reappear: the rabbi, the yellow cow, the violin, his birthplace Vitebsk, the cross, the pendulum, the flying figure the angel. All together they tell a poetic but disturbing tale.

● The rabbi protecting the Torah and the wandering Jew symbolize Chagall's relationship and belonging to a tradition and condition. The yellow cow is also linked to the theme since it represents an ancient, simple, known world compared to the unknown wandering fate of the Jewish artist.

● Abandoned, with nobody there to play it, the violin represents music forced into silence by the fall of the angel. Even the man in the upper left hand corner, surprised during his walk, seems no longer to dance in the air: deprived of the support of imagination he falls into the void.

● Two Christian themes appear on the right: the Virgin and Child, and Christ crucified. They signify redemption: the feeble light of the candle between them is compared to the glare of the Sun on the left.

● Above all this hovers the fantastic shape of the angel on fire whose hands have dropped the pendulum clock gone mad. It is the image of time which in a world of barbarity falls into the abyss of darkness.

◆ A LONG STORY
The rabbi on the left ends closes the painted tale while the Torah seems to suggest that by unrolling it the tale may continue. On the opposite side, wrapped in darkness only dimly lit by Christ's halo and by the red light behind the city, there is a cross untouched by the candlelight. In his biography Chagall recalls his visit to a rabbi and the many questions, "burning my tongue". The artist writes: "I wanted to speak of art in general and of mine in particular. Perhaps the rabbi could have breathed some of the divine spirit into me. Who knows? And I would have liked to ask him if the Jews were really the Chosen People as the Bible says. I would have also liked to know what he thought of Christ whose blonde figure had already been disturbing me for some time."

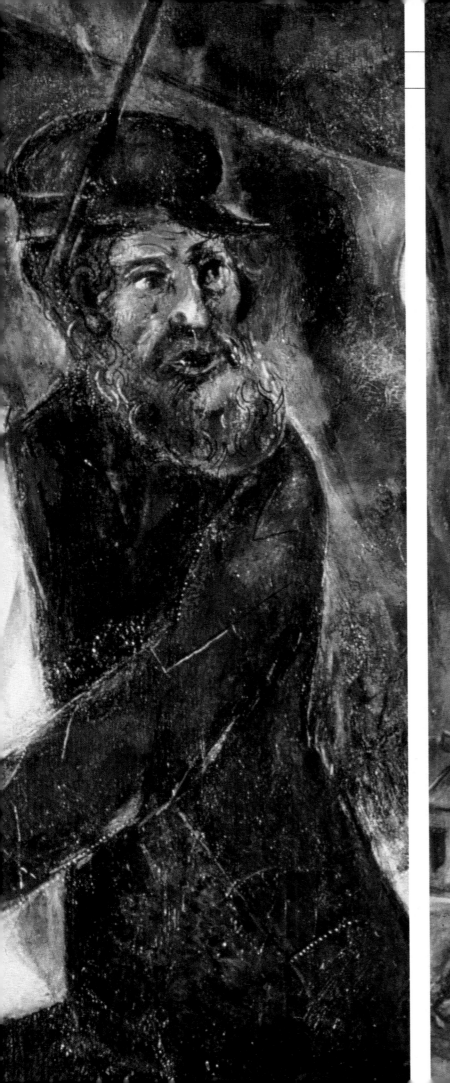
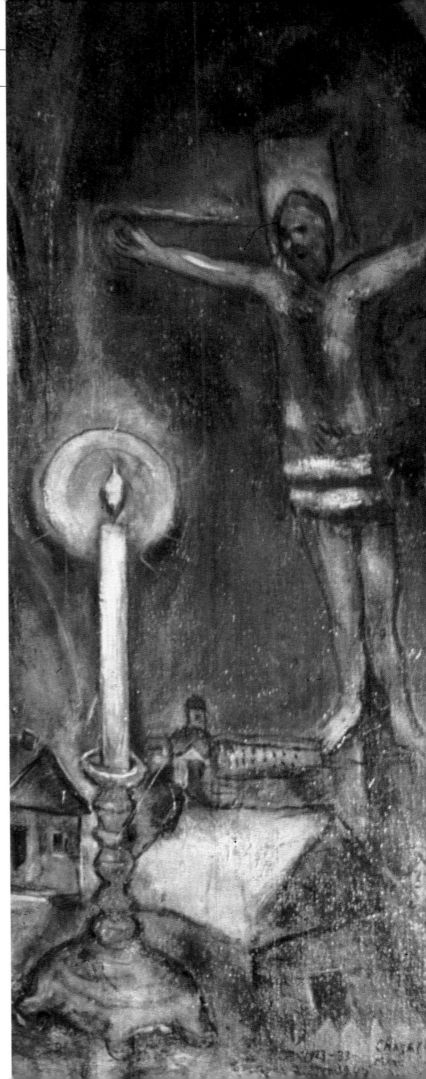

THE REASONS OF PSYCHIC FORMALISM

C hagall's painting is profoundly penetrated by a lyrical inspiration which betrays the artist's deep emotional involvement; he declared that "painting rebuilds the world" and that he meant to achieve "psychic formalism". This belief yielded strongly poetic but realistically connoted images.

● Thanks to his stay in France where he acquired a new sense of color, Chagall abandoned the monotonous dark chromatism of his early Russian paintings. In the *Falling Angel* he gives free play to deep, striking chromatic contrasts. The red of the angel's wing on the dark background contrasts with the bright yellow of the cow next to the violet-clad rabbi. The never naturalistic colors try to create that psychic shock always sought by the artist.

● Lines are soft and curved but almost cut into the canvas: in the lower part they follow an horizontal rhythm while they are absent in the upper half of the picture, dominated by the figure of the angel and by the man with the walking stick.

● It is an orderly, non-fragmentary composition albeit the numerous themes: the position of the figures create a series of rhythmic parallels obvious in the curve of the rabbi's body mirrored by the curve of the angel's wing.

● Even in the background the presence of cubist transparent objects amplifies the inter-play of lines and shapes and helps create uninterrupted space enhanced by the angel's wings: they unite the lower part of the painting with the upper, less crowded half.

● In the *Falling Angel* Chagall's fantastic personality achieves intense heights of expression conveying strong themes through an unsuspected control of formal elements. The artist states that the "psychic shock" induced by his paintings is "always motivated by plastic reasons" including the strength of color and the sensitivity of line and space.

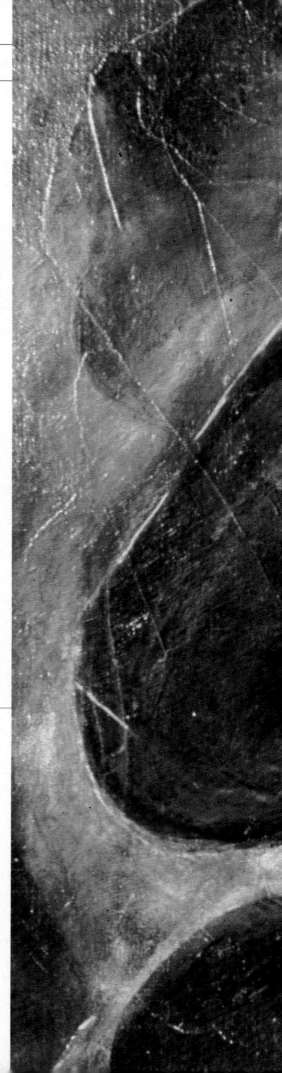

◆ A WORLD UPSIDE DOWN

A black line, thick and sure, defines the body of the green-faced man who seems to have become lost during a walk, surprised by some incomprehensible event: astonishment, not fear, appears on his face. The strange character moves in a transparent space made up of sharp, broken lines. In *My Life* Chagall wrote: "God, perspective, color, the Bible, shape and lines, tradition and all those things we call 'human', that is love, protection, family, school, education, the words of the Prophets and even life with Christ, all has been lost. Perhaps sometimes doubts assailed me too, and in those moments I painted an upside-down world cutting the heads of my figures, tearing them to pieces and letting them fly to some corner of my paintings.

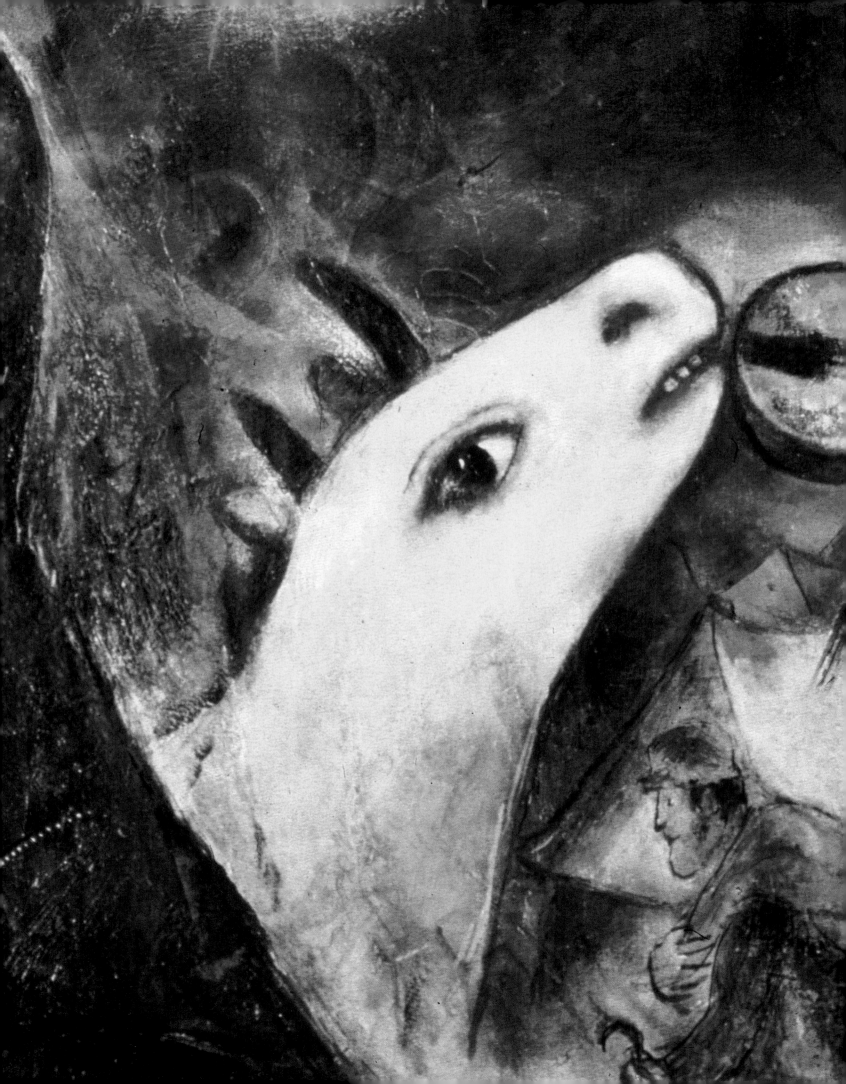

CHAGALL

◆ **A FIGURE IN THE NIGHT**

A small figure, dark tones and soft lines, moves away from the city with an attitude of surrender and a small bundle on his back. This character tells a common story: he image of the man leaving his home in the dark night while the city sleeps is the quiet paragraph of a realistic novel. Over his head, a violin: the bow continues the diagonal line which starts from the bundle on the wandering Jew's back and guides the eyes of the spectators' towards the great red angel, fulcrum of the painting. Even the yellow cow, while looking at the spectator, points its muzzle at the angel as a sort of intermediary between the observer and the scene on the canvas.

◆ **FRANZ MARC**

Yellow Cow

(1911, New York, Solomon Guggenheim Museum).

The cow is a familiar symbol for Chagall. It represents peace and tradition: again and again it appears in his paintings in fantastic unnatural colors. The German artist Franz Marc (1880-1916) uses this theme in many of his paintings, almost solely devoted to animals, as a symbol of a primitive world linked to a cosmic divine order. In the strong tension of its lines, Marc's *Yellow Cow* expresses vitality and energy. By painting only animals Marc criticised modern civilisation; Chagall's cow is instead a descriptive element of an unfolding tale and shares life with humans.

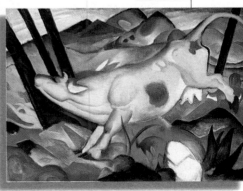

MYSTICAL PERSONALITY

A reserved man whose hands were "too delicate" to push barrels as his father had done, since a young man Chagall sought a profession which would not make him "turn his back on the stars and sky" and which would allow him to "find the meaning" of his life. However, as the artist said "in my country nobody before me had ever mentioned the words art and artist."

● Chagall came from a Jewish Hasidic family. This culture, unlike the orthodox Thalmud one, which forbade human images, was dominated by an irrational mystical spirit in which the sacred and pagan, reality and miracles joyously blended together. In this environment Chagall's spiritual world came into being.

● He was always deeply bound to his childhood, to the colorful celebrations and traditions of his home town, Vitebsk, which can be found in many of his paintings. Chagall's art feeds on these loving memories and impressions and refuses all kinds of intellectualism.

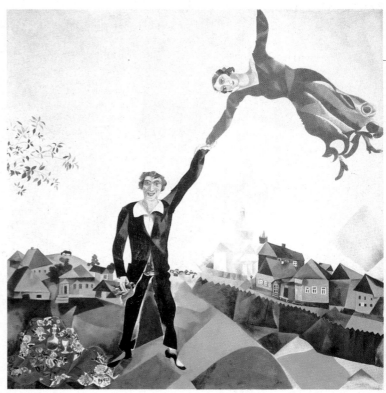

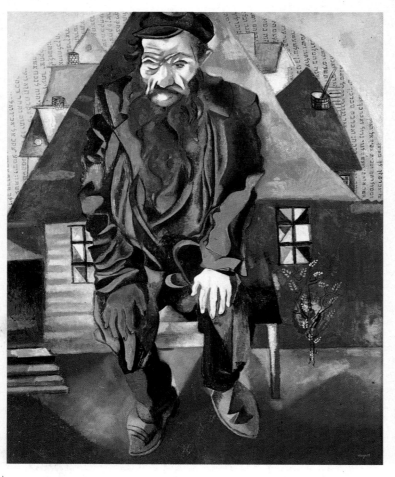

● Although attentive to any new trend in art, Chagall was a loner: bound to his idea of an art far from both realism and abstract spiritualism. A friend of painters and intellectuals such as Ricciotto Canudo, Guillame Apollinaire, Blaise Cendrars, with them Chagall shared a time of exciting research, discussion and debate. These were the very friends that supported his pictorial research, made of poetic associations which display an invisible reality; these sensitive avant-garde intellectuals joined Chagall in his search into the mystery of all things.

● Chagall often suffered financial hardship and nurtured the legend of his poverty by saying that at the market in Paris he could only buy one herring, eating one day the head and the following the tail. Nonetheless, he soon got used to the elegant environment of the Art Salon where he introduced himself as the cosmopolitan, anti-conventional, dreamy artist.

● In his self-biography "*Ma vie*", written between 1921 and 1922, at the early age of thirtyfour, Chagall wrote: "My name is Marc, I have a sensitive soul and no money but people say I have talent."

◆ PROMENADE (THE STROLL)
(1917-18, Russian Museum, St. Petersburg)
In a symphony of colors, ranging from intense, different hues of green to the transparent sky, Chagall celebrates his love for Bella who, like a kite, moves gently in the sky.
Of Bella, Chagall wrote: "I only had to open the window and together with her, the blue sky, love and flowers rushed in.
Dressed all in white or all in black she has been like a soul floating in and around my paintings, an ideal for my art."

◆ I AND THE VILLAGE
(1911, New York Museum of Modern Art).
In faraway Paris, Chagall recalls his home village in a vision inspired by memories.
Figures, colors, and characters overlap with no relation to time; in the center, the two images of the painter and of the cow around which a poetically transfigured world revolves.

◆ JEW IN RED
(1915, Russian Museum, St Petersburg).
In the old Jew's intense expression, long red beard and different colored gloves, Chagall has captured the innermost image of the character: in Hasidic culture the inner mood with which one leads life is worth more than simple obedience to rules.

VARIATIONS OF COLOR

Chagall's delicate, quick hand lays large strokes of colors on the canvas, each time stirring their material consistency from an almost transparent layer to a dense bulge.

● From Leon Bakst in St. Petersburg, young Marc learned the art and technique of putting together contrasting colors by investigating chromatic relationships. He also learnt how to create the simplest forms without attacking the two-dimensional nature of his canvas.

● Chagall's major resource is this sure, free use of color, supported and enhanced by an overall solid composition. A basic stage in his development occurred when he met the fauves and Cubism: the artist abandons the pasty, earthly colors of his early Russian period and discovers structural analysis of forms.

◆ COUNTRY LIFE (THE BARN; NIGHT; MAN WITH A WHIP) (1917, New York, Solomon R. Guggenheim Museum). This oil on cardboard shows Malevič's (1878 - 1935) influence in the geometrically abstract, monochrome concept of forms; however, Chagall does not give up his poetic world and uses the typical characters of his paintings.

● This ensures greater freedom of expression. In the first Parisian period color obediently follows outlines but is laid out in modular backgrounds which, from an intense hue, progressively become transparent. Later, the line in the drawing is almost unnecessary, the fluid brushstrokes define the object through soft, fading colors which Chagall derived from Claude Monet (1840-1926) and Pierre Bonnard (1867-1947).

● When in winter 1911-1912, the artist moves to an atelier bigger than his tiny room in Montmartre, even his paintings increase in size. Between 1921 and 1933, a particularly peaceful decade, Chagall paints on small size canvases: when faced with the horrors of war, he however felt the urgent need for large spaces for his poetic narration as if it were charged with a sort of cathartic task.

◆ THE FIDDLER (1912 - 13, Amsterdam, Stedelijk Museum). In the years of financial hardship, Chagall is forced to use table cloths as a support for his paintings: he lets the pattern of the material seep through: this expressive mode was later used by the cubists.

◆ VERVE (Nice, Marc Chagall Museum). An illustration for the Bible, a feat nobody since Rembrandt had tried. Chagall devoted many years to the task and also traveled to Palestine to become more acquainted with the settings.

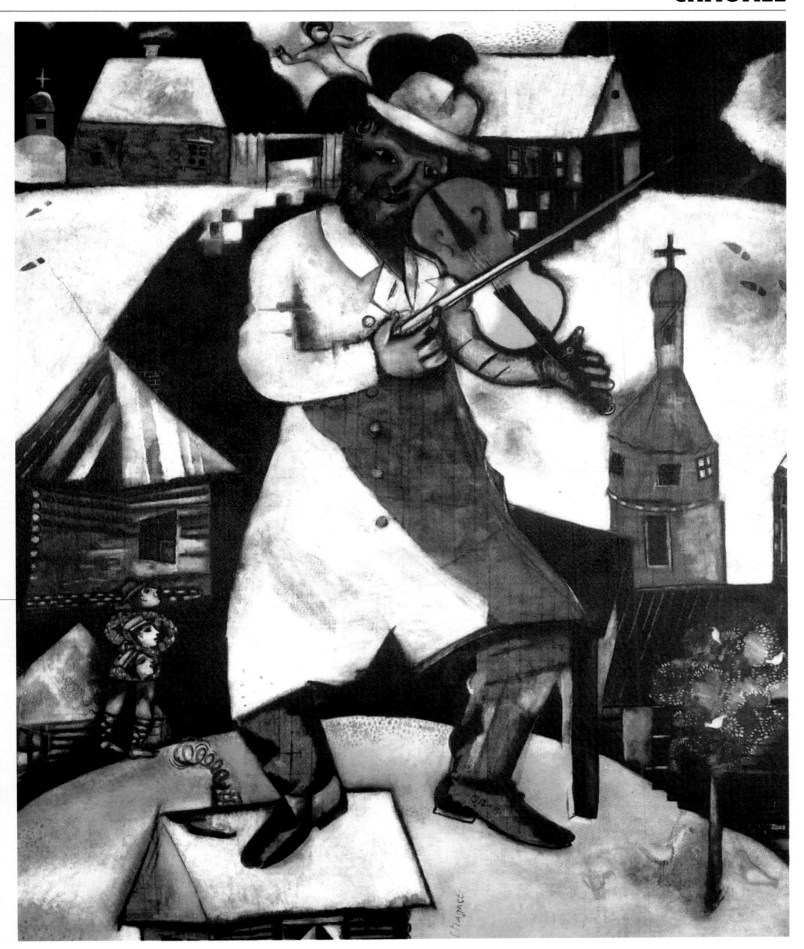

LIFE AS A WORK OF ART

I n *My life*, Chagall relates how he decided to avoid his father's hard fate, the same his family had chosen for him. He declares his firm intention to be an artist and tells of the excitement when, with his mother, he visited the painter Jehoda Pen to show him his drawings: "Even as I climbed the stairs I was intoxicated and excited by the smell of colors and paintings". For some time Chagall attended Pen's studio but, in 1907, almost penniless, he went to St. Petersburg where he attended the school of Leon Bakst, one of the most famous painters in town. Here Chagall met Mstislav Dobuzhinsky who introduced him to the group *World of Art*, a symbolist avant-garde movement whose poetics boosted Chagall's idea of the superior essence of art and imagination.

● The works from this period contain the core of the artist's future themes and are close to that Russian popular art the *World of Art* group was rediscovering. Chagall, like other Russian artists such as Natalja Goncarova (1881-1962) and Michel Larionov (1881 - 1964), was inspired by the boards which decorated Russian shops and by popular prints. The painter revisited these suggestions and gave them a classical breadth by referring characters and situations to traditional icons: an example is in this period's key painting in which the birth of his brother is represented as Christ's nativity. Moreover, the event is placed in an almost theatrical atmosphere, very close to Bakst's stage designs.

● It was the master who encouraged Marc to go to Paris where his art would get acquainted with new ideas. His life would bask in that unknown freedom which, as a Jew, he was denied in Russia. Marc recalls " I was not authorized to live in St. Petersburg nor did I have the even smallest place to live in: I was bed-less and penniless."

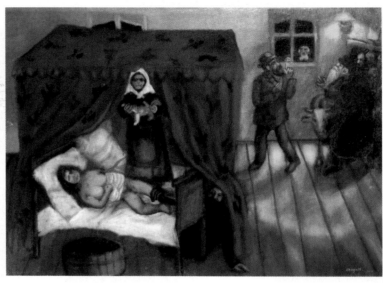

◆ BIRTH
(1910, Zurich, Kunsthaus).
The painting represents the birth of Chagall's younger brother, an event also described in the artist's biography. The characters which try to enter the house belong to the same, curious, participating community which in the *Russian Wedding* (1909, Zurich, E.G. Bührle collection, below) follows the wedding procession, traditionally lead by a fiddler, through the streets of Vitebsk.

◆ THE SABBATH
(1910, Cologne, Wallraf-Richartz Museum)
Van Gogh's art was a major element in the development of Chagall, as may be noticed in this painting. Chagall borrows composition, light and hues from the Dutch painter's *Night-Cafe-interior* modifying the atmosphere which here is vividly relaxed. The domestic family interior is portrayed in bright, lively colors with no interest in naturalism

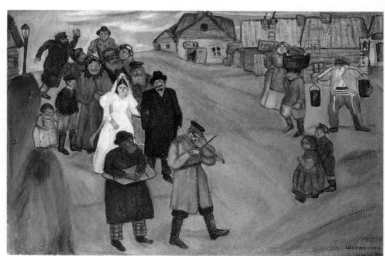

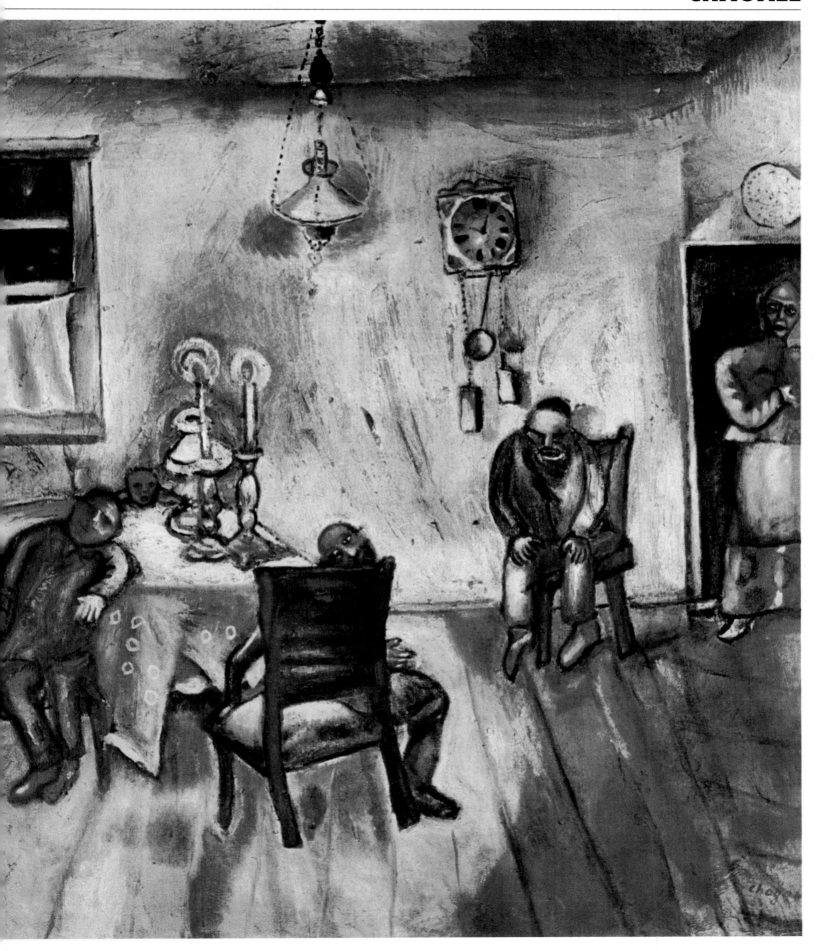

PERMANENT RESEARCH

A t Bakst's school, Chagall's paintings are called "meaningless scribbles". The artist understands that his art is too far from the epic realism or symbolism which were very popular in Russia at the time. Unwilling, but firmly convinced he had to leave a country where his art was mocked, thanks to a government grant, Chagall left for Paris.

● After a four-day train trip, the artist reaches Paris and settles at a friend's house in Montmartre. Homesick and shy, Chagall soon becomes enthusiastic of the vital and creative Parisian atmosphere. He actively takes part in the cultural life of the city and makes friends with artists and intellectuals, finally free from the yoke of incomprehension which had oppressed him in Russia: as the artist himself declared he seemed to "discover everything".

● Chagall moved into one of the La Ruche ateliers (living place for painters next to the slaughterhouses) and started to paint large paintings in which the influence of the cubists' formal language is evident. He meets the cubists and becomes particularly friendly with Delaunay: Chagall refused the cubists' sophisticated intellectualism but he appreciated their research on forms and their analysis of visual perception; both became fundamental to the development of his art.

● Color also played an important role as Chagall learnt from Matisse and the *fauves*. The *Drinking Soldier* or *Paris from the Window* well sum up Chagall's experience during this period. With his own charge of fantasy, the artist brightens up the balanced syntax of Cubism demonstrating he is no longer afraid of letting colors freely and fluidly flow across the canvas.

● As Chagall wrote in his biography, far from Russia and racial discrimination, in France he finally feels himself "a man". In *Self-portrait with Seven Fingers*, his figure dominates the atelier: outside the window, Paris, on his easel and in his mind, Vitebsk. "While taking part in that unique technical revolution in art ongoing in France, my thoughts returned to the soul of my village", stated Chagall, as if to say that his inspiration had remained loyal to itself and that living away from his home village only meant he was looking for more appropriate formal means and greater freedom of expression.

◆ SELF PORTRAIT WITH SEVEN FINGERS (1911-1912, Amsterdam, Stedelijk Museum).
In this self-portrait, where the cubist lesson is evident, Chagall places Paris in the background while on the right, amid the clouds, he sets the object of his thoughts, Vitebsk. Finally, he portrays himself in the act of painting.

◆ HOMAGE TO APOLLINAIRE (1911-12, Eindhoven, Stedelijk Van Abbe Museum, detail).
In a colorful geometrical universe, Adam and Eve move united in a single body. Beneath, around a pierced heart, Chagall sets the names of his French friends who first had welcomed his childish, visionary language.

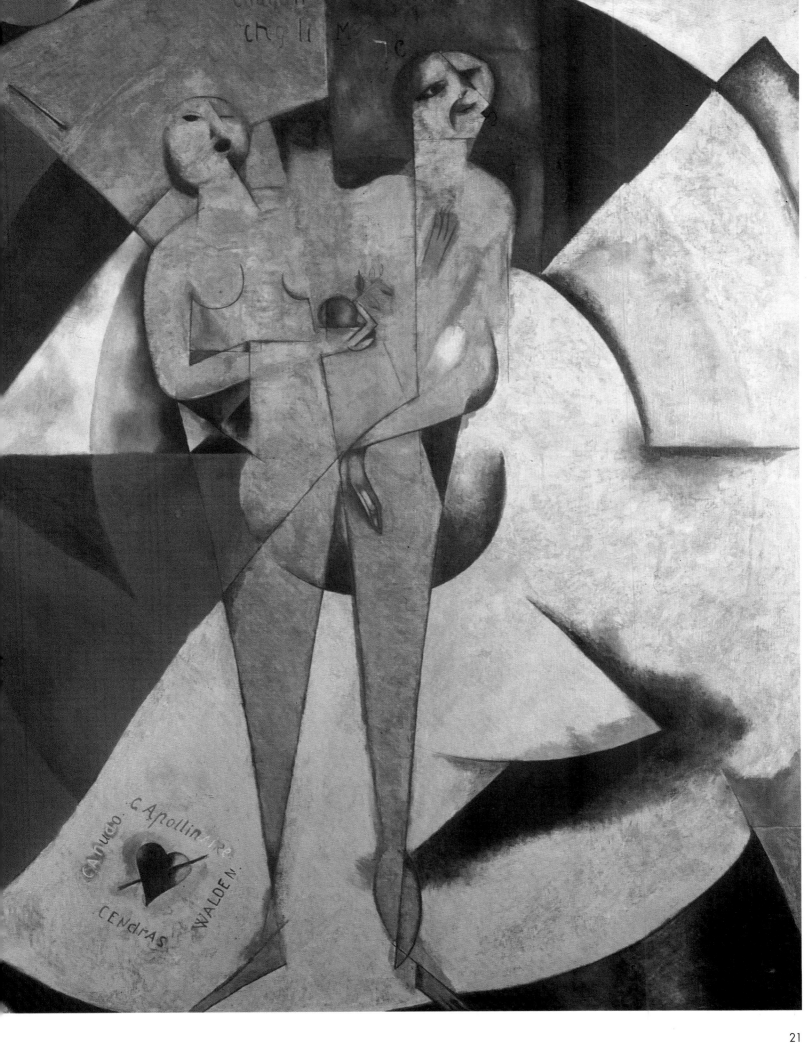

PRODUCTION: IN PARIS

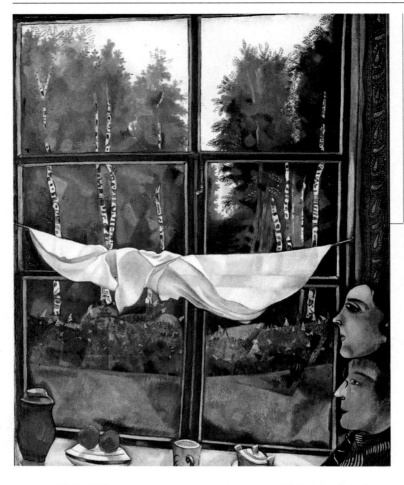

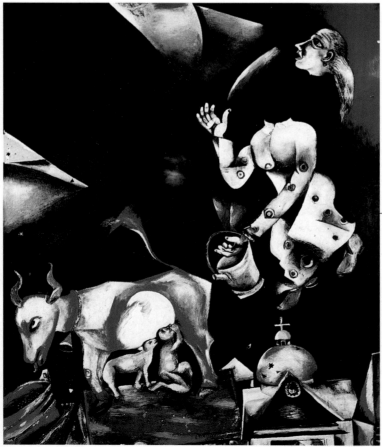

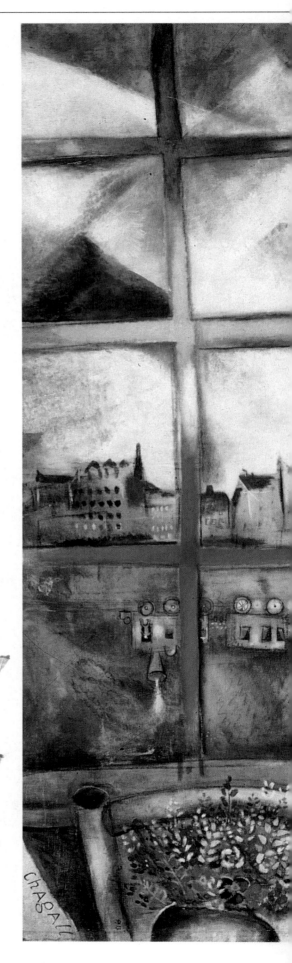

◆ WINDOW OF THE DACIA AT ZAOLCHA NEAR VITEBSK (1915, Moscow Tretjakov Gallery). A few objects, a teapot, a jar, a glass, a fruit bowl, throw shadows on the window sill; the open curtain makes it possible for the characters on the right, probably Chagall and Bella, to see the green grass and the white trunks of the high slim trees stained with color. The scene's focus, the colors laid in small compact strokes, the shadows on the characters' faces create a magic, timeless atmosphere.

◆ TO RUSSIA, WITH ASSES, AND OTHERS (1911-1912, Paris, Georges Pompidou Centre). Chagall chooses the language of fairy tales to set free his imagination and tell a story where he is the main character: set down in painting his life and memories become more universal. The lack of a naturalistic background allows the figures to move freely in space, to fly over roof tops, to "lose their heads", as in the case of the peasant woman with the bucket. Hard at work, she lets her mind dream and wander in the realm of her thoughts.

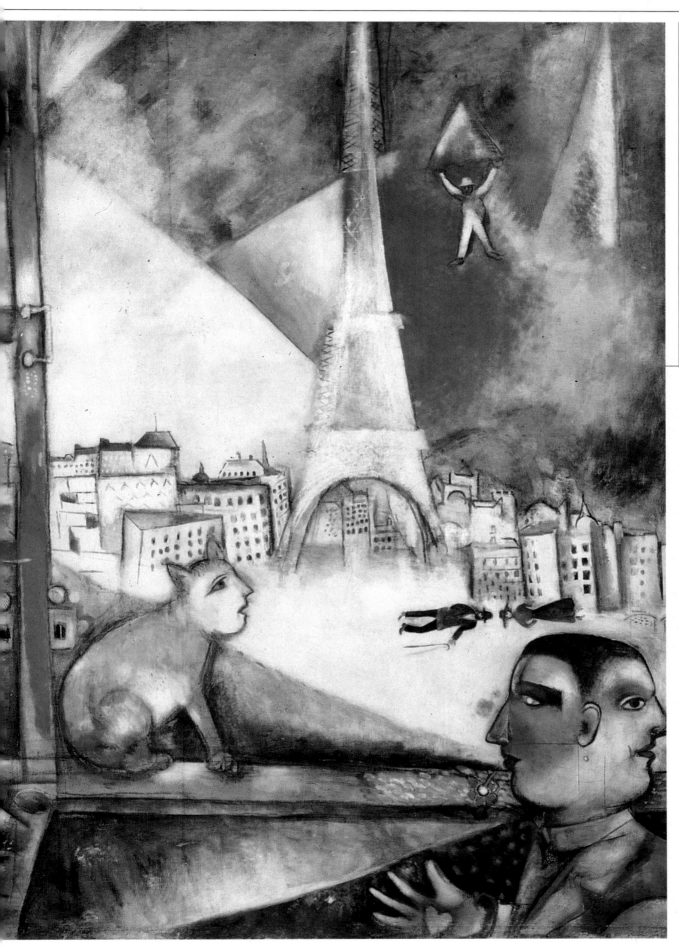

◆ PARIS THROUGH THE WINDOW
(1913 New York, Solomon Guggenheim Museum).
In Paris, thanks to Robert Delaunay and his Russian wife Sonia Terk, Chagall meets the world of "Orphic Cubism" in which the orthodox cubists' analytical view of objects is replaced by inner reality and by the expression of the secret charm of things.
The Cubist breaking down of planes, allowing distant times and places to exist alongside each other was the most appropriate way to express this reality. For Chagall this meant he could free the images of his dreams, fairy tales, and mind, in a space which appears real but is indeed illogical.
In this painting, perspective yields an environment which seems real: the cat with a human face, the two-headed character, the two figures flying towards each other, the upside down train and the colors, all join in this game of imagination.

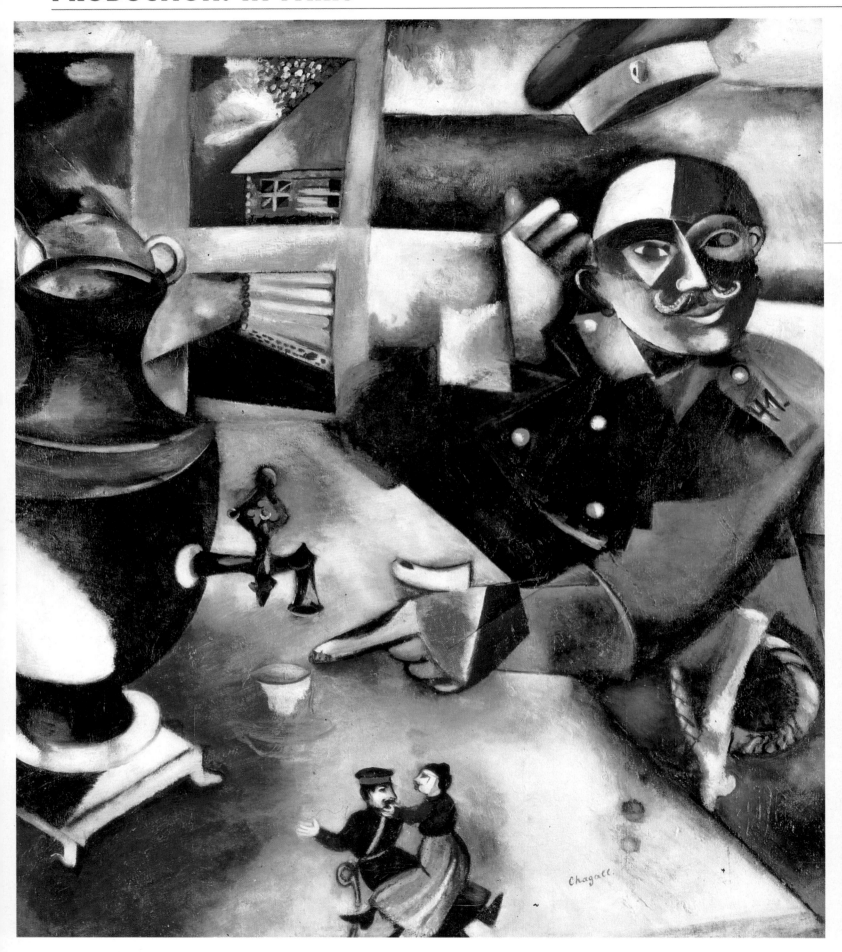

♦ THE DRINKING SOLDIER
(1911-12, New York, Solomon Guggenheim Museum).
Each Friday, Chagall met with the group of Cubist painters at the poet Canudo's house.
He thus came in touch with the Paris avant-garde.
This painting shows how Chagall made use of the new style's rigor in composition without giving up the magic of his colors, of his figurative world and memories.
In the painting a tiny couple dances on the table, the cup under the samovar is smaller than a thumb and the soldier's hat flies off his head by itself.

♦ POET (HALF-PAST THREE)
(1911 Philadelphia, Philadelphia Museum of Art)
The painting is dedicated to Blaise Cendrars, the poet who was Chagall's closest friend.
The critic Viktor Misisano called the painting " an anti-cubist manifesto.
By no mere chance, contrary to reason and common sense, the main character is a poet with his head upside down: chin at the top and nape on his neck.
With fascinating humor and provocative imagination, the painter (poet-painter) defends another concept of art: absolute creative freedom and free play of imagination".

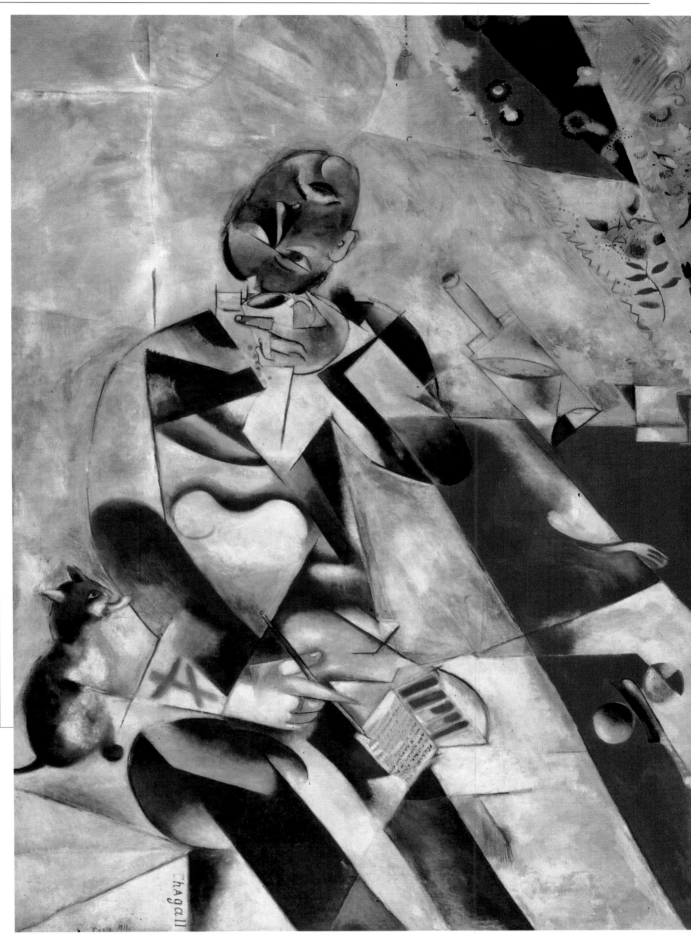

REVOLUTIONARY UTOPIA

In Paris Chagall met Walden, an art merchant who in 1914 organized the painter's first personal exhibition in the editorial office of his magazine "Der Sturm" in Berlin: "My paintings made a great show in Potsdammerstrasse while not far away cannons were being charged". In the city museums Chagall is charmed by the paintings of Giotto and Masaccio and calls their art "simple and eternal".

● While on a short visit to his family in Russia, war broke out trapping him there for 8 years. Chagall pours into his paintings the soundness of composition which

to Vitebsk. In 1918, Chagall was appointed Commissar of Fine Arts by Lunacharsky who he had made friends with in Paris.

● Chagall sets enthusiastically down to his new task: his first decree regards the phantasmagoric decoration of the town with banners and arches inspired by his drawings; he set up a museum, held conferences and debates, established the second

◆ FEAST DAY (RABBI WITH LEMON) (1914, Düsseldorf, Kunstsammlung Nordrhein-Westfalen). The essential composition of this painting underlines the symbolic meaning of the figure. The upwards movement characterizing the composition leads the eye of the onlooker beyond the head of the Rabbi on which another tiny figure lightly stands.

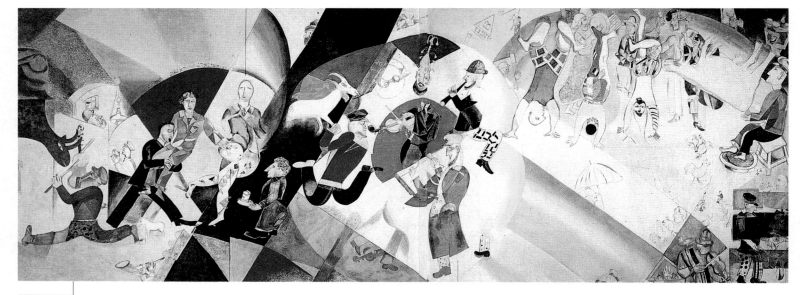

◆ INTRODUCTION TO THE JEWISH THEATRE (1920, Moscow, Jewish Theatre). In 1920, appointed by the critic Abraham Efros and the director Aleksej Granovskij, Chagall decorates the Jewish Theatre. In forty days, the hall which he covered with religious allegories, truly became 'the environment of painter'. Chagall represented himself, his clients and the Arts: Music, Dance, Theatre and Literature.

had given the work of those early Italian artists their ancient, magical aspect.

● During this period Chagall painted "everything he saw" wandering around Vitebsk with his first master, Jehoda Pen, to capture the landscapes and faces of his fellow villagers: the intense, noble faces of the rabbi so often present in his paintings.

● In 1915 he marries his beloved Bella and moves to St Petersburg to avoid military service. When revolution broke out the couple returns

Russian school of Art which he called the Academy.

● Chagall put all his efforts into this institution. It became a source of disappointment due to conflicts with Kasimir Malevič, who supported a non-objective, methodologically rigorous art opposed to the creative freedom ideally pursued by Chagall. In 1919, while Chagall was away, the school was turned into a Suprematist Academy.

● Albeit the distance between the suprematist principles and the poetic realism of Chagall, some of his paintings in this period show the influence of Malevič's. *Composition with Circles and Goat,* 1920, demonstrates how Chagall could make use of any formal novelty, as he had done before with cubism, and still be loyal to his own inspiration.

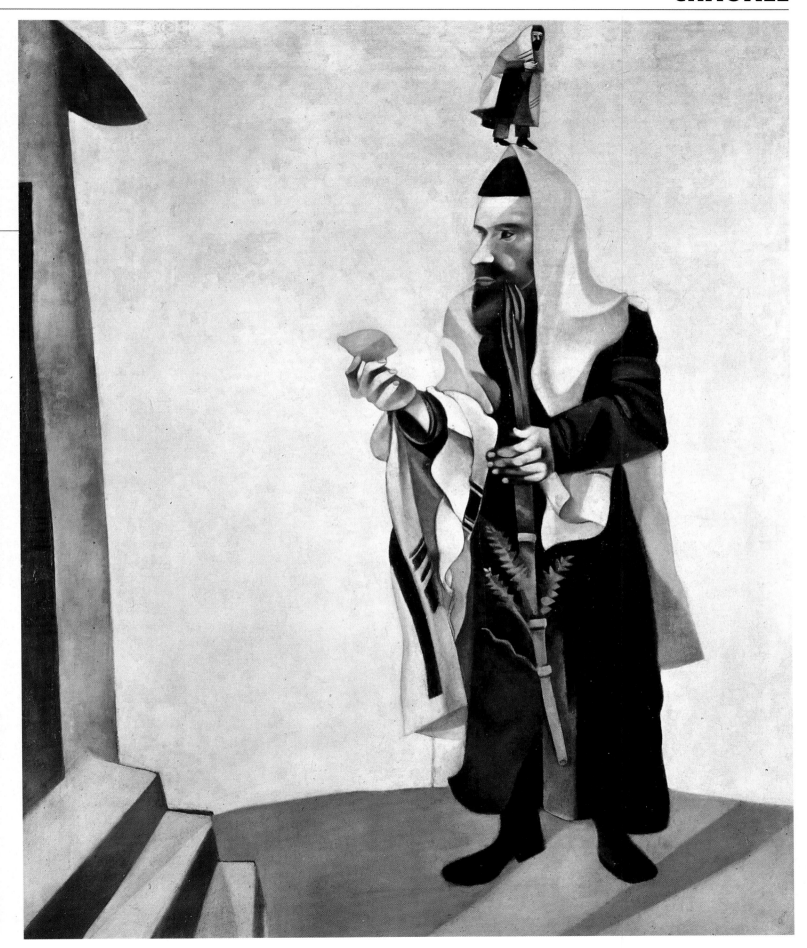

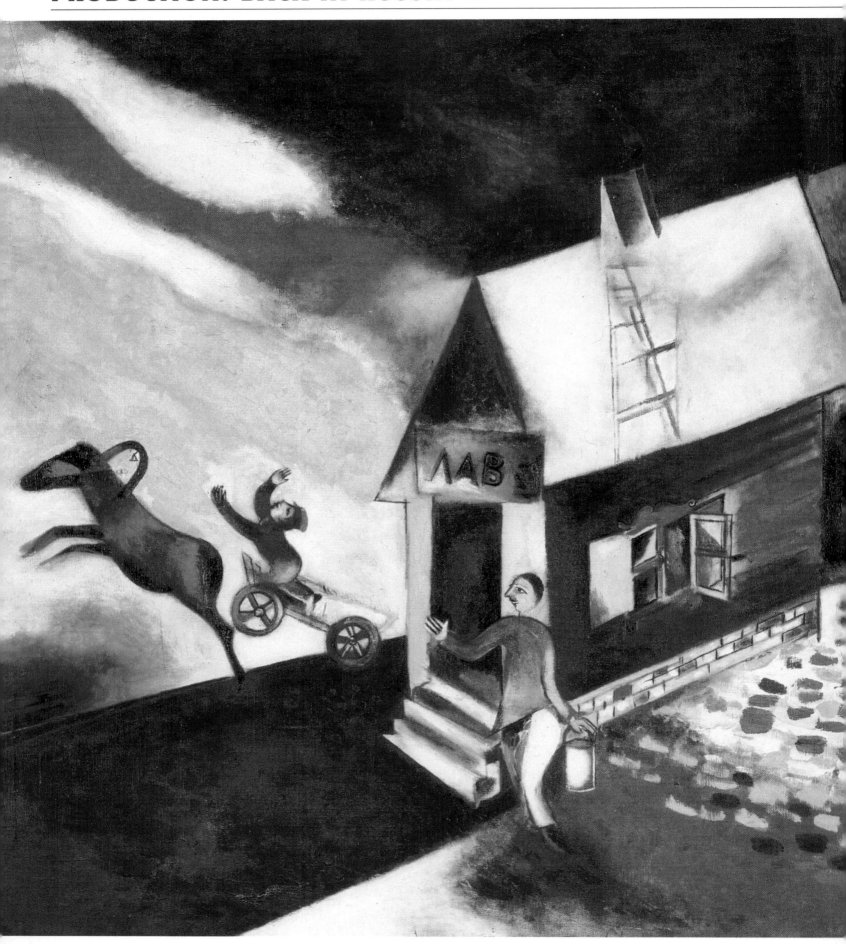

◆ **THE FLYING CARRIAGE**
(1913, New York, Solomon R. Guggenheim Museum)
The painting is dominated by the musical use of color rhythmically spread out on the canvas. On the left, the pictorial substance is laid down in fluid compact brush-strokes while on the right it is shattered in small drops. All naturalistic rendering has been ruled out. One wheel of the magical carriage is the color of the earth while the other is the green of the horse about to take off into a sky bright with all the colors available on the painter's palette.

◆ **THE GREEN VIOLINIST**
(1923, New York, Solomon R. Guggenheim Museum)
The violinist is one of the most popular characters in Chagall's kaleidoscopic world: sometimes the main character of a painting or, more often, a narrating element. The Green Violinist, with different colored gloves and shoes, plays a peaceful tune while in the village, the cow and the tiny man next to the musician's face look at the small pink figure flying high above, in a calm, suffused, atmosphere.

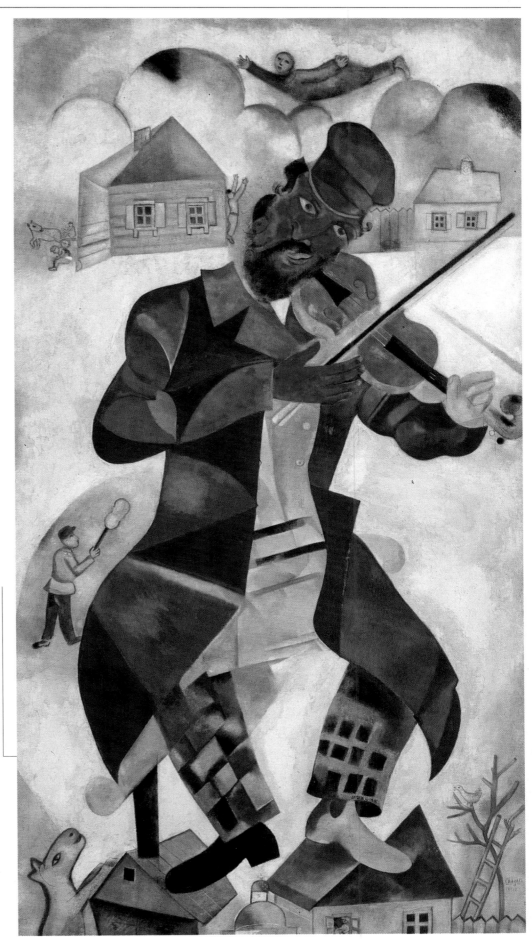

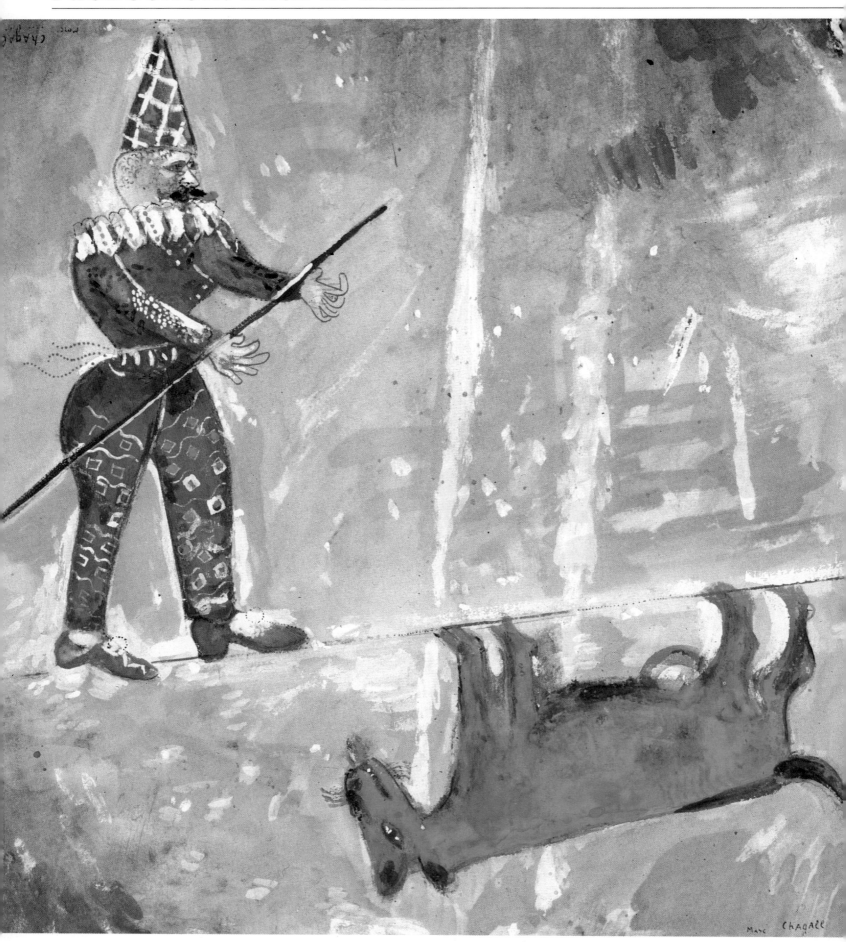

◆ COMPOSITION WITH CIRCLES AND GOAT (1920)
In 1915 Malevič painted *Black Square on White Background* putting forward the idea of art without reference to reality. Chagall does not share this principle but feels the suggestive power of simple colors and forms.
In this *Composition* he forces colors within soft clear lines, exploiting the coarseness of his support in the green area and creating a more abstract space.

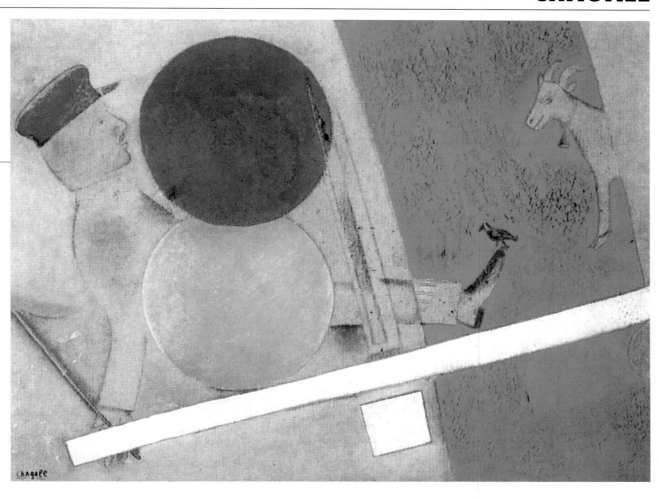

◆ ACROBAT
(1930, Paris, George Pompidou Center).
After having discovered the magic atmosphere of the circus thanks to the editor and art dealer Ambroise Vollard, Chagall paints a set of 19 tempera on cardboard devoted to his friend.
The world of jugglers and of horseback riders joyously enters his art: in this painting a green goat and an acrobat face each other on the unlikely rope of imagination.

◆ FANTASY OF ST. PETERSBURG
(1942, New York, Museum of Modern Art).
In New York, Chagall produced some set designs for the Ballet Theatre including this draft for Aleko: a vision of St. Petersburg.
A fabulous white horse hovers in the stormy sky. For Chagall theatre was a visionary world where his metaphors could be freely expressed.

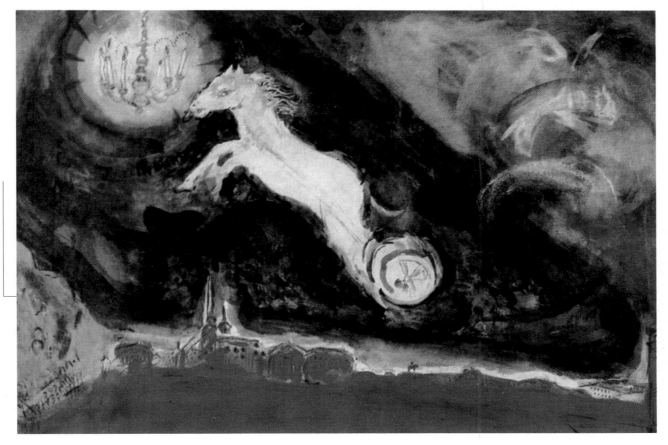

AN ANGEL ON HIS MIND

Chagall's return to France is the beginning of a very happy period: his painting becomes expansive and light in a pattern of thin liquid colors which fill small canvases.

● His skyline, however, was soon to darken as the artist once again felt the urgent pressure of History. His sadness may be seen in *Solitude,* 1933: the figure of the Jew is wrapped in a dark halo while the white angel flies away leaving him alone.

● His fight against hard existential conditions is embodied by the characters in *Revolution* in which Chagall expresses the uneasiness and excitement of the crowd: in the middle of the picture Lenin performs as a mountebank

● The same uneasiness, which continued to trouble the artist, generated *White Crucifixion,* chromatically delicate and full of real references and memories and dominated by the figure of Christ, symbol of suffering.

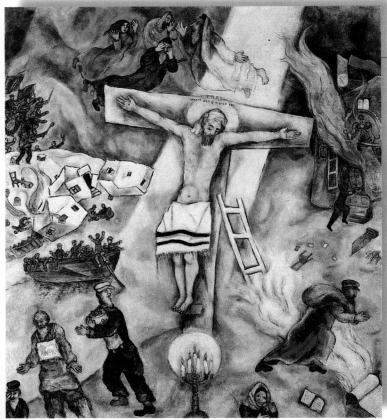

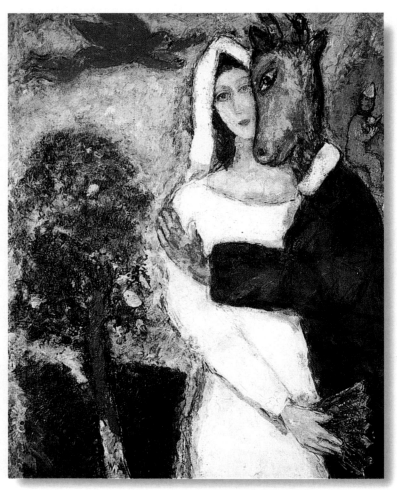

● In 1941, Chagall the Jew was arrested in Marseille. The intervention of the United States avoided his transfer to Germany. The artist sought refuge in New York, observing the events in Europe from afar. In his paintings colors become increasingly independent as in contemporary American abstract art: the typical figures are used as words in a language and lose some of their expressive power in favor of colors.

● In 1944 his wife Bella died: "There is darkness ahead" wrote Chagall in despair; he could not paint for ten months. Four years later the artist returns to France for good. He is 61 and very famous. Up to his death in 1985 his life would be "wonderful" and his art dominated more and more by color. In 1967, he was invited to Russia by the Minister for Culture, but Chagall did not have the heart to go to his home town Vitebsk, completely changed by the War. His safe harbors were was now France, his second wife Vava, and the house in Vence where, on the evening of March 28, died the artist who Picasso said "had an angel somewhere in his mind".

◆ WHITE CRUCIFIXION
(1938, Chicago, Art
Institute of Chicago)
For Chagall white was
the color of horror
and pain: a ray of light
strikes the dying
Christ surrounded by
several figures from a
forlorn world, one of
them a small boat
vainly striving to sail.
Fire and banners,
candles and stairs,
books, chairs, clocks,
all seem to float in the
still, unchanging space
of History.

◆ WINDOW
(1924, Zurich,
Kunsthaus).
The peaceful
atmosphere of this
painting stems from
the light transparent
hues of the sky
reflected on the
window panes;
the window looks onto
a silent landscape
painted with an almost
impressionist touch.
Humans, symbols,
even the desire to tell
a tale are missing as
the painter's eyes
capture only the pure
beauty of nature.

◆ A MIDSUMMER
NIGHT DREAM
(1939, Grenoble,
Musée de Peinture et
Sculpture).
Chagall was very fond
of this painting
which he took with
him to New York
in his suitcase.
Titania and the
donkey-headed Bottom
from Shakespeare's
comedy here represent
the painter and Bella,
locked in a tender
embrace, in a
harmony of colors.

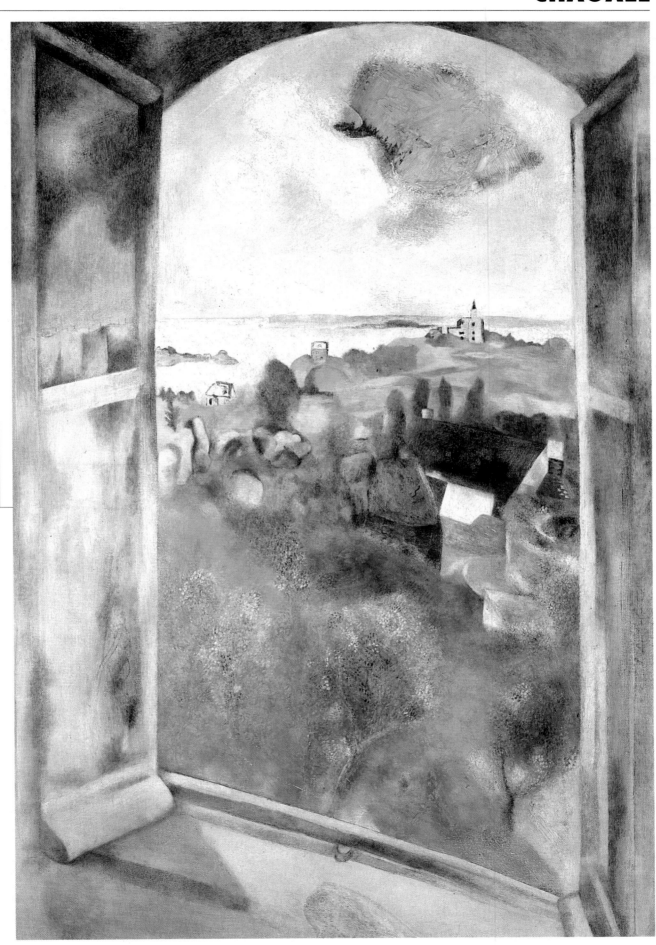

♦ THE CEILING
OF THE OPERA
In his last years
of activity Chagall
became more and more
involved in great
decorative cycles,
executed in a variety
of techniques.
In 1963 the Minister
for Culture, Malraux,
invited him
to paint the Ceiling of
the Paris Opera

Theatre.
The great circular
dome celebrates the
Olympus of classical
music: the images
of great musicians
(Wagner, Mozart,
Ravel), together
with the characters
of their works,
move in space;
the monuments
of Paris are
in the background.

◆ THE MYTH OF
ORPHEUS
(1977 Private
Collection).
The heroes of Greek
Mythology,
an unexplored world
for Chagall, appear
in his later works
as elements of an
harmonious world
in which different
cultures peacefully
co-exist.

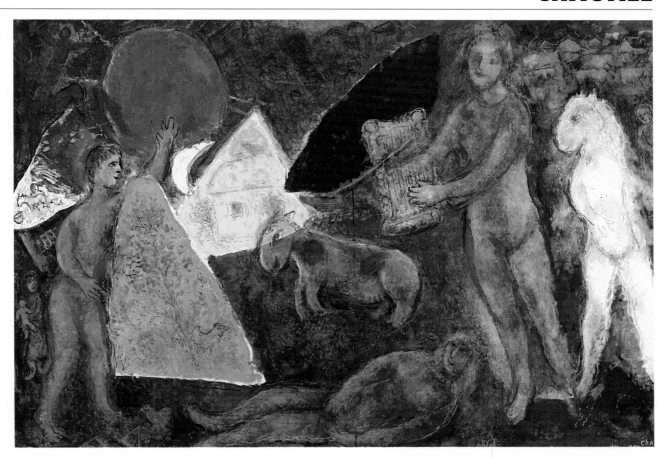

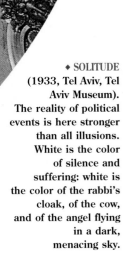

◆ SOLITUDE
(1933, Tel Aviv, Tel
Aviv Museum).
The reality of political
events is here stronger
than all illusions.
White is the color
of silence and
suffering: white is
the color of the rabbi's
cloak, of the cow,
and of the angel flying
in a dark,
menacing sky.

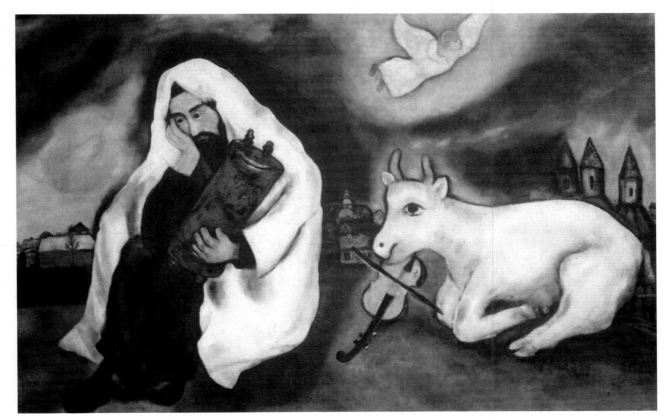

PRODUCTION: RETURN TO FRANCE

◆ REVOLUTION
(1937, Paris, Private Collection)
This is the preparatory study for *Revolution*, an enormous painting which the artist partly destroyed.
In 1917 the Revolutionary army occupied the Winter Palace and set up a provisional government, later removed by Lenin. The latter appears as a mountebank standing on one hand on a kind of stage while the crowd watches on.

◆ FLAYED OX
(1947, Paris, Private Collection).
The strong expressiveness of the flayed ox makes it a tragic symbol and leads back to the *White Crucifixion*.
Behind the hanging animal a nocturnal, still image of Vitebsk with other figures dear to the painter: amongst them the sweet face of Bella who had died three years earlier.

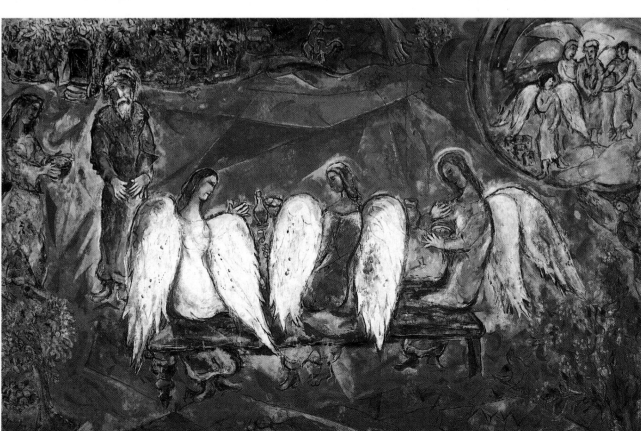

◆ ABRAHAM AND THE THREE ANGELS
(1956-1958, Nice, Marc Chagall Museum).
With visionary colors and fluid lines, Chagall paints the tale of Abraham, one of the subjects of seventeen paintings with episodes from Genesis, Exodus and the Song of Songs, donated in 1966 to France by the painter. They are now in the Museum of the Biblical Message in Nice, entirely designed and decorated by Chagall.

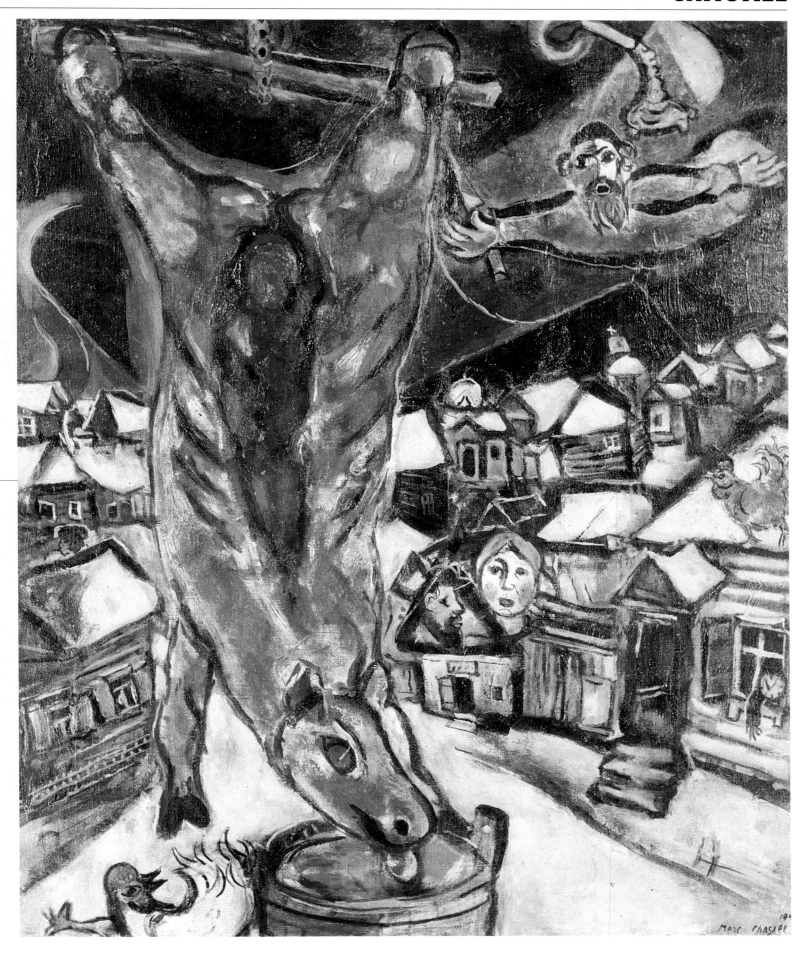

LIGHT AND COLOR

"I did not look at the Bible, I dreamt it", said Chagall. In 1956 the artist completed a set of etchings for the Bible. They had been commissioned by the French art dealer and collectionist Ambroise Vollard who since 1923 had encouraged the painter to try etching and for whom Chagall had already illustrated Gogol's *Dead Souls* and La Fontaine's *Fables*. The painter's freedom of expression is even more visionary thanks to a particular use of this technique: Chagall removes all outlines and his figures become evanescent, pictorial; the fluid sign condenses in certain points and from there becomes again filamentous. More than his paintings, Chagall's etchings portray the energy of inspiration: images never narrate and are never captions. The painter's sensitivity turns the text into a starting point for the fantastic flight of imagination.

● The chromatic explosion required to express his inner world in his works, leads the artist to mosaics and stained glass in which color becomes matter. In the marvelous stained glass windows of public buildings in France,

● DEATH OF PENELOPE AND TELEMACHUS (1968, Nice, University, School of Law). Chagall's universal message and his love for color reach their formal synthesis in mosaics. The artist used them to decorate Nice University with the tales of Ulysses, a new subject for his art.

Switzerland and Palestine, Chagall shows he is a master in solving problems set by the particular structure of space. Color and light change his typical images into a wonderful cosmogony enhancing their poetic and religious meaning.

● In the last years of his prolific life there is a growing urge for a monumental work in which space would express his spiritual yearning. Such a feeling inspired the creation of the Museum of the Biblical Message in Nice, almost a "Shrine of Love where the visitor may feel peace, spirituality, a sense of religion and life". Many of Chagall's works are to be found in this unique setting, devoted to spiritual meditation. It is an unmatched feat, a museum dedicated to a living artist which is also a religious building: decorated with 17 large paintings, tapestries, mosaics and stained glass windows, all by the same artist, all by Chagall: "in art, as in life, all is possible when founded on love".

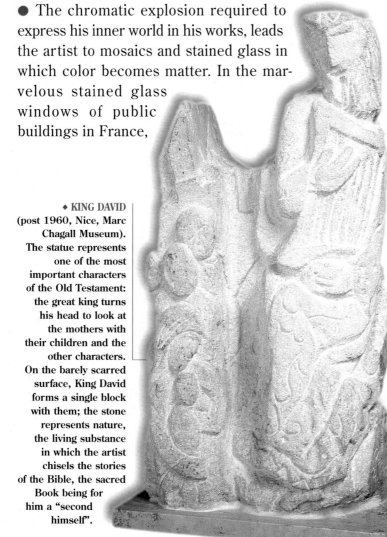

● KING DAVID (post 1960, Nice, Marc Chagall Museum). The statue represents one of the most important characters of the Old Testament: the great king turns his head to look at the mothers with their children and the other characters. On the barely scarred surface, King David forms a single block with them; the stone represents nature, the living substance in which the artist chisels the stories of the Bible, the sacred Book being for him a "second himself".

● STAINED GLASS WINDOWS (1968, Metz Cathedral). In the transparent colored glass through which light filters, Chagall tells the tale of Jacob's struggle and of the Angel of Sacrifice of Abraham. Light enhances the religious value of the great figures, and as a divine symbol gives them even greater expression.

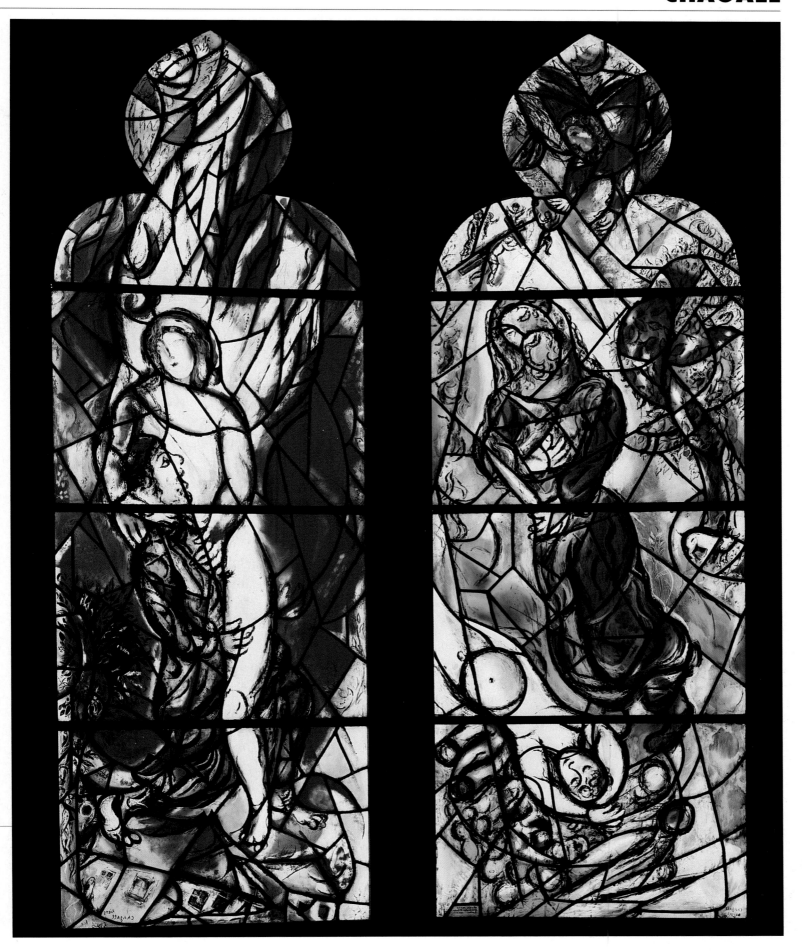

DANCES, COLORS AND GUERNICA

From the very beginning of his career, Chagall had the opportunity to meet many of the protagonists of the artistic and cultural scenario of the age. At Bakst's school, the easel of Vaslav Nijinsky, the great, provocatively dressed ballet-dancer, was next to Chagall's. Nijinsky was first dancer in the famous Russian Ballets, a fantastic exotic show with acrobatic pieces supported by the work of choreographers, decorators, costume designers, singers and dancers. The idea of total art represented by the Russian Ballets was proposed by Sergei Diaghilev in Paris in 1909 where it reaped great success.

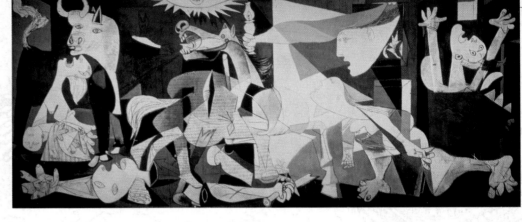

● During his first stay in France (1910-14) Chagall lived at the Ruche, one of the buildings of the Universal Expo which had been transformed into a residence for artists by the sculptor Alfred Boucher. The low cost of the ateliers attracted a large number of artists; there Chagall met many of the protagonists of the so called "*Ecole de Paris*": Modigliani, Leger, Soutine, Zadkine. Many political refugees also stayed there: Lenin, Trotsky and Lunačarsky who became Chagall's friend.

● It was Lunačarsky who, in 1918, after becoming Commissar for Education, placed Chagall in charge of the Fine Arts at Vitebsk. In this period of social and civil reform, people were both excited and disturbed; art became an active force in social renewal. This may easily be seen in the celebrations for the revolution when squares and monuments were for days transformed into huge stages.

● In 1937, at the Paris World Expo, Picasso exhibited *Guernica*, a violent attack to the inhuman horrors of war. In the same period and with the same intent Chagall painted his *White Crucifixion*.

● During the Second World War, Chagall fled from Europe to New York which was already becoming the new capital of Art and where several artists from Europe were living as exiles. Chagall made colors express his feelings, as he moved closer to the abstract art of American artists such as Jackson Pollock (1912-1956), Arshile Gorky (1905-48), Willem de Kooning (1904) in which contents are determined by the movement of the paint brush and by the combination of colors.

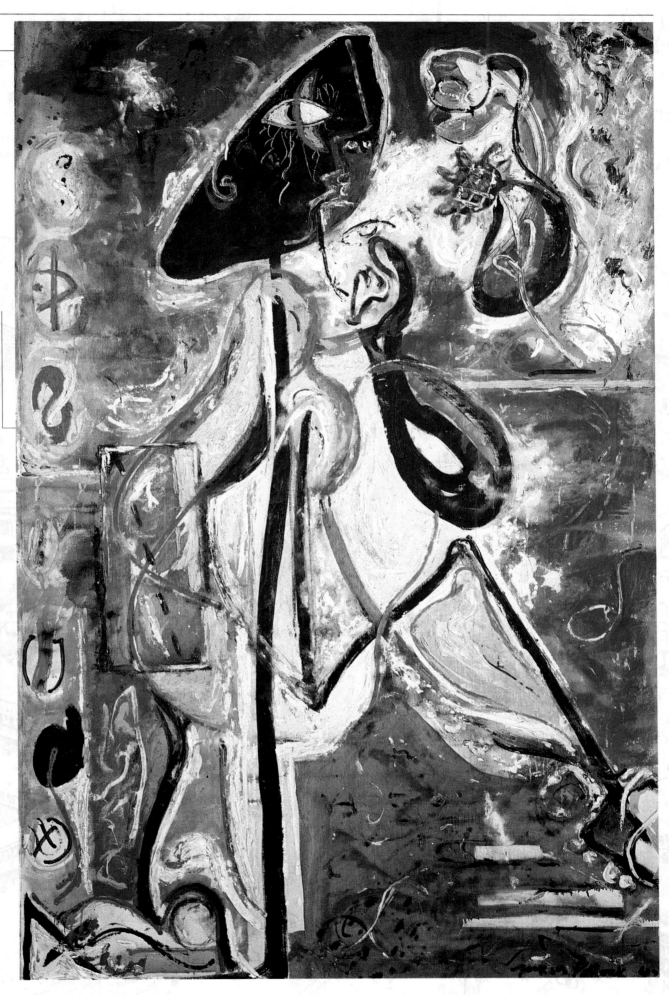

◆ PABLO PICASSO
Guernica
(1937, Madrid, Casón del Buen Retiro).
The barbarity of war explodes in the wide open mouths of Guernica.
An almost graphical painting where colors disappear, replaced by the white, grey and black of the newspaper photos of the destroyed city.

◆ JACKSON POLLOCK
Moon Lady
(1942, Venice, Peggy Guggenheim Collection).
The fantastic figure of the Moon Lady recalls Indian totems; through color and freedom of touch, Pollock introduces irrational and primitive modes of expression full of magic and spiritual meaning.

◆ VASLAV NIJINSKI
Nijinski worked with Diaghilev (on the previous page in a 1906 portrait by Leon Bakst, St Petersburg, Russian Museum).
Chagall recalls: "I had heard that Nijinsky was already a famous ballet-dancer and that he had been sacked by the Imperial Theatre for the way he dressed. His easel is next to mine."

EMANCIPATION OF ART

"Art is above all a state of the soul", stated Chagall. In agreement with the widespread trend of abandoning all naturalistic and rational ideas in painting, Chagall's paintings are the immediate transposition of feelings and emotions.

● In 1919, the poet Rubiner wrote to his friend saying that his art had given birth to expressionism. Chagall is one of the ideal fathers of this movement in which emotional and spiritual experience produces a strong chromatic, formally deformed language.

● "With Chagall and only with him metaphor has triumphantly entered the field of painting", wrote André Breton in 1945.

● Long before, in 1918, Guillame Apollinaire, who still had not invented the term Surrealism, called the paintings of Chagall "supernatural".

● The painter is considered a pioneer of this movement

◆ BELLA WITH WHITE COLLAR (1917 Private Collection) The figure of the young lady with a black dress and white collar and cuffs majestically dominates the space of the painting. Behind, an unreal sky, rings gently blending one into the other. Similarly the leafy green trees of the wood below blend into each other, and the tiny mother and child figure seems to suddenly appear from within the foliage. The expression on Bella's face recalls the Madonna with Child of primitive Italian painting.

◆ FELICE CASORATI *Silvana Cenni* (1922, Turin, Private Collection). The hieratic figure of the young lady with a distant, still gaze, is the center of composition in a prospectively measured, classical orderly space. It is an image in which real and unreal seem to blend as in many other paintings of the same period. After the war there was a "return to order", to the classical aspects of images from Italian 14th and 15th century Painting, which influenced Chagall too.

too, although he never joined the group: "I remember Apollinaire's first visit to my atelier at La Ruche in 1912. Standing in front of my paintings from 1908-1912 he used the word 'surnaturalisme'. I could never have imagined that 15 years later there would have been a surrealist movement". The importance of dream and vision for Chagall is close to the Surrealist anti-rational concept of art and poetics of the subconscious.

● Chagall's moment of classical realism when he returned to Vitebsk in 1914, is the herald announcing Picasso's neoclassicism, and that of the *Valori Plastici*, the Italian movement between the two World Wars, which represented a return to tradition, with fixed figures and unreal landscapes.

● In spite of the more or less direct influence Chagall had on some of the movements of his Age, the most precious legacy left to future generations was his belief in the independence of art and in the superior value of artistic creation. An idea which meant boundless freedom in expression and painting.

◆ SALVADOR DALÍ
The Persistence of Memory
(1931, New York, Metropolitan Museum of Modern Art). The Spanish artist produces metaphysical timeless landscapes on which visionary and realistic elements simultaneously appear: ants, eyelashes, deformed clocks, rocks and even a hidden self-portrait. The Surrealists' fantastic art stems from the need to free psychic reality from the control of logic. Dalí had his own very personal interpretation of this, which he called "critical-paranoiac method".

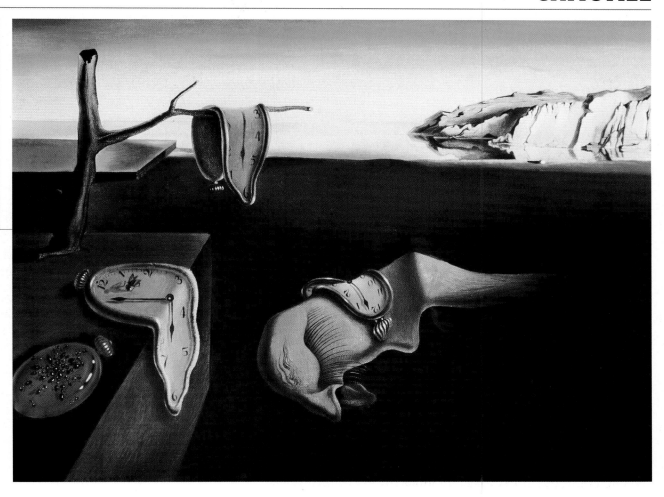

◆ MAX BECKMANN
Sinagogue
(1919, Frankfurt, Städtische Galerie im Städelschen Kunstinstitut). The German painter (1834-1950) shares with Chagall the fate of a wandering Jew, always in search of refuge. Beckmann's apparently fantastic but topographically accurate representation of the Jewish quarter in Frankfurt, encloses all his world: the streets with the small group of people returning home from a carnival feast, the dome of the synagogue, the cat and the first evening lights.

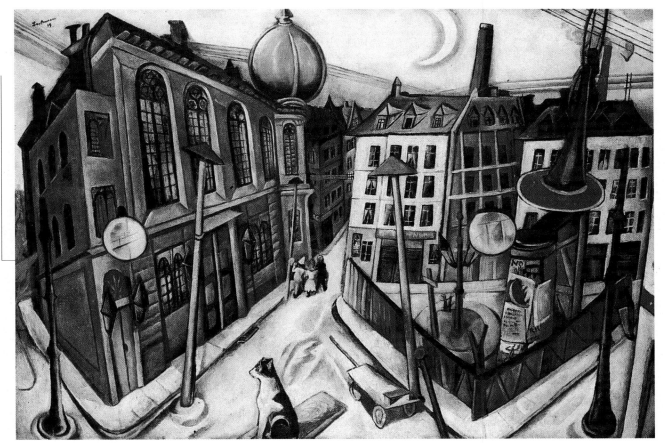

THE ARTISTIC JOURNEY

For a vision of the whole of Chagall's prduction, we propose here a chronological reading of his principal works.

◆ GIRL ON THE SOFA (1907)

An almost photographic pose of the artist's sister Marussia painted by Chagall during a visit home after he had moved to St. Petersburg. It was one of his first paintings and shows some uncertainty in the anatomy of the figure sitting on a flower-decorated sofa. Spatial depth is missing and the dark deep, hues produce a severe atmosphere.

◆ THE DEAD MAN (1908)

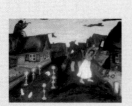

The painter said that inspiration for this painting came from his wish to paint whatever he saw from his window. Showing a death scene in the village streets, Chagall produces a feeling of mystery formally expressed in a slight perspective and in the movements of the characters, clearly disproportioned if compared to the buildings

◆ RUSSIAN WEDDING (1909)

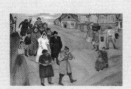

In St. Petersburg, Chagall uses typical motifs to represent his longing for home. In this painting, the artist is telling his own personal life: the joy in meeting Bella Rosenfeld. A procession led by two musicians moves through the village streets, interrupting the activities of the characters on the left.

◆ MY FIANCÉE WITH BLACK GLOVES (1909)

The pose Chagall chose to represent his beloved, Bella Rosenfeld, gives a solid feeling to the whole composition. The head, turned sideways and the movement of the hands confer an immediacy which betrays Chagall emotional involvement. The black and white contrast is modulated by the brownish color of her flesh.

◆ BIRTH (1910)

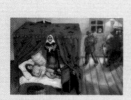

In his self biography, Chagall recalls his brother's birth, symbolically rendered in painting: "The house was full of serious looking men and women, whose dark bodies obscured daylight. Noise, whispers; suddenly the sharp cries of a baby. Mother, half-naked, was lying in bed looking very pale. My youngest brother was born."

◆ RECLINING NUDE (1911)

The composition and disturbing atmosphere of this small painting recalls Manet's Olimpia. In Paris, Chagall visits art galleries and museums and concludes that "Here in the Louvre, standing in front of the paintings of Manet, Millet and others, I realize why my ties with Russia and Russian art are so weak, and why even my language is foreign to them".

◆ I AND THE VILLAGE (1911)

In this joyous, poetic painting, the artist relates his memories and loves in a kaleidoscope of moving colors and forms and expresses his longing for and strong ties with his home village Vitebsk. A radical composition which recalls theOrphic cubism of Robert Delaunay gives the painting its dynamic aspect and strong expressive power.

◆ HOMAGE TO APOLLINAIRE (1911-12)

The painting is a homage to the poet who had called Chagall's paintings "surnaturel" considering them an anticipation of surrealism. Chagall used a mixed technique: gold and silver powder were sprinkled on the canvas, over the oil colors, thus making it more precious. In the center Adam and Eve united in a single body symbolize the myth of androgyny, an important alchemist motif.

◆ BIRTH (1912)

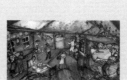

A large size painting for a theme dear to Chagall already represented in a 1910 work: from the latter Chagall recovers some images such as his mother half-naked and bleeding on the bed, the crowd at the door. All the scene is however transported into a more anecdotal, discursive, atmosphere due to cubist influence.

◆ THE FIDDLER (1912-13)

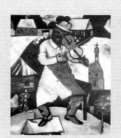

In the darkness of night a huge green-faced and blue-bearded figure plays the violin. A symbol of the fiddler who in Jewish communities accompanies all most important events, weddings, funerals, religious celebrations. The painting had a great success and was printed on Walden's German magazine "Der Sturm". In 1913, Walden himself organized a personal exhibition for Chagall in Berlin.

◆ SELF-PORTRAIT WITH WHITE COLLAR (1914)

Chagall depicts himself as a young man with delicate features and pink cheeks. Bella's mother had once said to her daughter: " Listen, I believe he powders his cheeks red. What kind of a husband can such a man ever be?". This ethereal portrait, lacking all male features, reveals the fear the dreamer Chagall had of being enrolled in the army.

◆ THE SMOLENSK JOURNAL (1914) ???

Inspired by Cezanne's *Card-players*, the painting transmits a sense of anxiety. The only readable word on the newspaper on the table is 'Voina', war. Space is closed, locked; color has vanished, the range of colors is limited to black and yellowish hues and to the green halo cast by the lamp. In this doomsday atmosphere two people sit in silence, confused.

◆ RECLINING POET (1915)

In its composition and general effect this painting recalls Gauguin's art. It is a visual transposition of the dream of a happy life, close to nature. The painter refuses the nightmare of war and yet another leave-taking from his family: he escapes into an intact world. His soul, full of poetry, is comforted by a known and loved environment.

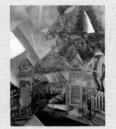

◆ CEMETERY GATES (1917)

On the open gates of the cemetery there is an inscription from Ezechiel's Old Testament Vision "Thus says the Lord your God: I shall open your graves and bring you forth, my people, into the land of Israel." It was painted when the Bolshevik revolution granted civil rights to all Jews.

◆ THE PAINTER TO THE MOON (1917

When Vitebsk was completely covered by the decorations created by Chagall and in the same moment when he had been appointed Commissar for Fine Arts, he was criticized by his colleagues for his very strange paintings with green cows and flying horses. With this poetic work Chagall firmly defends freedom of artistic creation and activity.

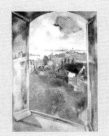

◆ THE WINDOW (1924)

Chagall's second stay in Paris was one of the happiest periods of his life. He looks at the soft atmosphere of the Impressionists and his paintings become expansive, liquid, fading. The colors of the landscape and sky reflect on the panes of the open window, welcoming daylight.

◆ THREE ACROBATS (1926)

Inspired by the circus, in 1914 Chagall had painted *Acrobat*. This magical world would become a constant feature of his work only 10 years later when his pictorial language was ready to represent such a fantastic theme. In the *Three Acrobats*, the magical atmosphere stems from the intense, misty colors and the position of the three figures.

◆ LOVERS IN THE LILACS (1930)

A simple thought linked to a deep feeling produces a romantic atmosphere nurtured by well known traditional symbols: flowers, the moon under a bridge, a tender embrace. All the space is taken up by a huge vase of flowers: two lovers nestle in its colorful. In a corner the Seine reflects the moonlight enhancing the visionary feeling of the image.

◆ SOLITUDE (1933)

The angel forsakes the Jew and leaves him alone with his Torah which can no longer provide comfort to his soul. Even the cow shares the atmosphere of sadness which envelops both man and nature (and the peaceful animal reminds of the words of the Prophet Oseas "Yes, Israel is as stubborn as a stubborn cow"). The black dressed man wrapped in a dark, disturbing shadow, is a remarkable pictorial image.

◆ REVOLUTION (1937)

Chagall uses the Circus setting with its mountebanks and crowds of spectators to depict a real event: the Bolshevik Revolution and Lenin's return from exile. Here the political leader is depicted in a clownish attitude. The painting does not relate facts but reactions and turmoil caused by political events. In 1943 the artist divided the painting into three parts.

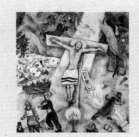

◆ WHITE CRUCIFIXION (1938)

Illuminated by a ray of unnatural white light, the White Cross stands amid events and symbols each separately described on a smaller scale. Chagall pours the suffering of his people and the horrors of War into the Christ figure, borrowed from Renaissance art, becomes an universal simbol in which Chagall represents the suffering of his people and the disaster of the war.

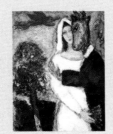

◆ A SUMMER NIGHT DREAM (1939)

Chagall very much loved this painting where he appears with the long face of a donkey, in the arms of his white-clad wife, while above an angel seems to grant them peace and joy as in a fairy tale. Inspired by Shakespeare's *Midsummer Night Dream*, the artist never parted from this painting which represents the dream of a refuge and of a warm embrace.

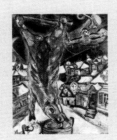

◆ FLAYED OX (1947)

Chagall here treats a classical motif already tackled by Rembrandt, and contemporaries such as Soutine and later on, by Francis Bacon. The striking expressiveness of the flayed ox transforms it into a tragic image: behind the animal hanging on a pole, the still, nocturnal image of Vitebsk with other typical characters and people

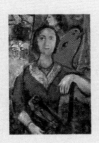

◆ VAVA CHAGALL (1966)

This is one of the few portraits Chagall painted. It is dedicated to his second wife, Valentina Brodskij who shared with him the peaceful last days of his long life. In the background some monuments of Paris, while on the left the ever present Vitebsk. Color is free and bright and its sharp contrasts give striking intensity to the image.

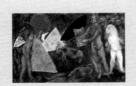

◆ THE MYTH OF ORPHEUS (1977)

This late painting shows Chagall's growing interest in Greek Mythology: The dark colors refer to the Hades Orpheus must enter to rescue Eurydice. The somber background overlaps with lively red and yellow geometrical forms; on the opposite side the figures seem absorbed by the darkness.

◆ THE GREAT PARADE (1979-80)

A colorful powder fills the canvas, small sensitive dots describe the joyous atmosphere of the circus where one may meet Chagall's famous characters. If Greek artists were looking for divine perfection, Chagall's painting wishes to depict an intact world full of warmth, feeling and beauty.

TO KNOW MORE

The following pages contain: some documents useful for understanding different aspects of Chagall's life and work; the fundamental stages in the life of the artist; technical data and the location of the principal works contained in this volume; an essential bibliography

DOCUMENTS AND TESTIMONIES

An unknown word

The following two passages are excerpts from the self-biography Chagall wrote in Russian, between 1921 and 1922, just before he left Moscow and his country for ever. The book was later translated into French by his wife Bella in 1931.

"In fifth form, this is what happened during a drawing lesson. An elder student in the first desk who had always pinched me, suddenly showed me a drawing on paper, a copy of 'Niva', *The Smoker*.
What, in full chaos! Leave me alone.
I can only just remember, but that drawing, by an idiot and not by me, immediately drove me mad.
A scavenger woke up in me
I rushed to the library, grabbed that huge edition of 'Niva' and copied the portrait of the composer Rubinstein, seduced by his crow's feet and wrinkles or by a fret and other illustrations; perhaps I even made up some.
I pasted everything on the walls of my bedroom.
I was familiar with back-street jargon and the few words of everyday language.
However, such a fantastic, literary word, a word from another world, the word 'artist', yes, perhaps I had heard it somewhere but in my town nobody had ever said it.
It was so far from us! I would never have dared to say it.
One day, a classmate came to see me and when he saw my room and drawings he cried out:
" Listen, are you a real artist?"
'What is an artist? Who is an artist? Can even I... be...'
My pal went away without any explanation.

I suddenly remembered that somewhere in our town I had seen a big sign, like the ones on shops: 'Jehoda Pen School of Drawing and Painting'. 'Right', I thought, "The die is cast. I just have to join that school and become an artist'. I will shatter my mother's illusion to make me a shop assistant, an accountant, or even better, a photographer."

[Marc Chagall: *My Life*]

Bella

In his self-biography Chagall recalls the dazzling moment he first met his future wife Bella, the lively impressions of affinity he had right from the beginning, the emotional upheaval caused by her great black eyes.

"This unknown girl's visit and musical voice seem to come from another world,
....
Who is she? I'm frightened. No, I want to meet her, to get close to her.
But she is already saying goodbye to Thea. Just a quick glance at me and away.
Thea and I go out for a walk. On the bridge we meet her again.
On her own, completely on her own.
I suddenly feel I should not be with Thea but with her.
Her silence is mine. Her eyes, mine. It was as if she had always known me, known everything about my childhood, my present, my future; as if she had been watching over me, known my innermost thoughts although it was the first time I met her.
I felt she was my woman.
Her pale complexion, her eyes. How big, round and black they are. They are my eyes, my soul.
Thea seemed indifferent, estranged.
I entered a new house and never again did I leave."

[Marc Chagall: *My Life*]

Chagall Astonished

The poem which Blaise Cendrars dedicated to his friend shows how Chagall's symbols come from a real, suffering world; in his paintings the spectator may recognize his own character. With images stolen from Chagall's works, Paul Eluard creates a poem which evokes the painter's world as in a nursery rhyme.

Marc Chagall
"He Sleeps/ He is awake/ Suddenly he paints/ He grabs a church and paints with it/ He grabs a cow and paints with it/With a sardine/ With skulls, hands, knives/ He paints with a bull's tendon/He paints with all the grubby passions of a Jewish village/ Tormented by passion from remote Russia/ For France/ Dead heart and pleasures/ He paints with thighs/ Looks at bottoms/ Look at your face/ It's you, dear reader/ It's me/ It's him/ His bride/ The owner of the corner shop / The cowgirl/ The midwife/ In buckets of blood infants are washed/ Unending madness/ Muzzles spit fashion/ The Tour Eiffel as a corkscrew/ Crowded hands/ Christ/ He himself Christ/ All his youth on the cross/ Each new day a suicide/ Suddenly he paints no more/ He is awake/ Now he sleeps/ He strangles himself with a tie/ Chagall astonished/ Borne by immortality.

[B. Cendrars, in F. Walther, R Metzge, *Chagall*, Cologne]

To Marc Chagall
"Ass or yellow cow or horse/ Up to a violin / Man who sings as a bird / Who dances taking his woman by the hand / Couple wrapped in their Spring.
Gold of the grass, lead of the sky / Separated by blue flames / By the freshness of dew / The throbbing heart's bright blood/ A couple the first reflection / and in a cloud of snow / draws the fruitful vine / A face with moonlight lips / who never sleeps at night.

[P. Eluard, in F. Walther, R Metzge, Chagall, Cologne]

HIS LIFE IN BRIEF

1887. Segal Moshe is born in Vitebsk (Belarus) and soon changes his name to Marc Chagall. He is the eldest of the 11 children of a poor Jewish family: his father Zahar is a herring salter, his mother Feiga-Ita runs a small shop.

1906. Finishes public school, becomes apprentice of the painter Jehoda Pen.

1907. Together with his friend Meckler, moves to St. Petersburg to attend the school of the Imperial Society for the Protection of the Arts.

1908. After leaving the school of the Imperial Society and the private school of the painter Saidenber, he attends the Zvantseva school of Leon Bakst until 1910

1909. Meets Bella Rosenfeld, his future wife, at Vitebsk.

1910. Moves to Paris thanks to the editor of the magazine "Voshod" who enables him to stay in Paris for 4 years.

1911. His painting *I and the Village* is exhibited at the Salon des Indépendants. Chagall moves to La Ruche where he meets Léger, Modigliani and Soutine; makes friends with Cendrars, Apollinaire and Delaunay.

1912. Exhibits at the Salon des Indépendants and Salon d'Automne.

1913. Thanks to Apollinaire, Marc meets the German art dealer, Herwarth Walden who helps him take part in the first Berlin Autumn Exhibition.

1914. Walden organizes Chagall's frist personal exhibition in his gallery "Der Sturm". Chagall leaves Berlin for a brief visit to Russia but the outbreak of World War I forces him to stay there. All paintings left in Paris and Berlin are lost. In St. Petersburg he is forced to perform camouflage drills.

1915. On the 25th of July he marries Bella Rosenfeld at Vitebsk.

1916. His daughter Ida is born. The Dobitchna Gallery in St. Petersburg organizes an exhibition of his paintings. He also exhibits 45 paintings at the exhibition of the Knave of diamonds, a group founded by Malevich, Larionov and Goncharova.

1917. Following the October Revolution Jews are granted civil rights and Chagall thus becomes a free man.

1918. He is appointed Commissar for the Fine Arts at Vitebsk and director of the local Fine Arts Academy; Lissitsky and Malevič also teach in his schools.

1919. The Revolutionary Government buys 12 of his paintings on behalf of the State.

1920. Attacked by Malevič, Chagall resigns from his duties. He takes part in the first official exhibition of revolutionary art in St. Petersburg. He moves to Moscow and paints murals and decorations for the "Jewish Theatre'."

1923. He moves to Paris. Meets Ambroise Vollard for whom he illustrates *The Dead Souls*.

1924. First retrospective exhibition in Paris.

1926. First one-man exhibition at the Reinhart Gallery in New York

1930. First trip to Palestine to visit the places of the Bible for a set of etchings commissioned by Vollard.

1931. His self-biography, *My Life*, is translated into French by his wife Bella and published

Self Portrait with brushes, 1909

in 1931. Chagall and his wife travel to Tel Aviv to dedicate a new museum.

1932. Travels to the Netherlands where for the first time he sees Rembrandts etchings. Travels also to Italy and Spain. In Germany, the Nazis destroy his paintings.

1933. A huge retrospective exhibition of his paintings takes place in Basel.

1934. Travels to Spain where he becomes an enthusiast of El Greco's art.

1935. Witness to a pogrom in Poland.

1937. Becomes a French citizen; visits Florence.

1939. Receives the Carnegie Award for painting. When War breaks out he moves to France with his paintings.

1941. Arrested in Marseille for racist rea-

sons, Chagall manages to escape to New York thanks to intervention of the Emergency Rescue Committee. He lands in New York on June 23rd, the day the German army invaded Russia.

1942. In Mexico, he prepares the stage designs and costumes of Chaikovsky's ballet Aleko for the New York Metropolitan Opera.

1944. On September 2nd Bella dies as a consequence of a viral infection. Chagall is in despair and unable to paint for several months.

1945. Starts painting again and designs set and costumes for Stravinsky's *Firebird* for the New York Metropolitan Opera.

1946. Retrospective Exhibitions in New York and Chicago. Returns to Paris for the first time after the war.

1947 Exhibitions in Paris, Amsterdam and London.

1948. Returns to Paris for good and settles in Orgeval near Saint-Germain-en Laye; receives the First Prize for Graphics at the 25th Biennale in Venice.

1948. Moves to Sain-Jen-Cap-Ferrat on the Côte d'Azur; paints murals for the Watergte Theatre of London.

1950. Settles at Vence

1952. On the 12th of July marries Valentina Brodsky, nicknamed Vava; travels to Greece with her. La Fontaine's *Fables* published with illustrations by Chagall.

1955. Starts work on the *Biblical Message* cycle of paintings which will be completed in 1966.

1957. First mosaic mural: *Blue Cock*.

1958. Designs set and costumes for Ravel's ballet *Daphne and Chloe* for the Paris Opera Theatre.

1959 Awarded Degree honoris causa by the University of Glasgow.

1962. Becomes honorary citizen of Vence.

1964. Finishes decorating the Ceiling of the Paris Opera, commissioned by De Gaulle and Malraux.

1967. Two retrospective exhibitions are organized in Zurich and Cologne to celebrate his eightieth birthday.

1973. The Marc Chagall National Museum *The Biblical Message* is inaugurated in Nice.

1974. Outstanding welcome in Chicago for the unveiling of the mosaic, *The Four Seasons*.

1977. Awarded the Grand Cross of the Légion d'Honneur; becomes honorary citizen of Jerusalem.

1978. One-man exhibition at Palazzo Pitti, Florence.

1985. On March 28th Chagall dies at his home in Saint-Paul-de-Vence.

WHERE TO SEE CHAGALL

Below is a list with technical information on Chagall's main paintings which may be seen in collections or in places open to the public. Works are listed in alphabetical order according to the city in which they are exhibited. The information consists of title, date, technique and support, size in centimeters.

AMSTERDAM (HOLLAND)
The Fiddler, 1912-13; oil on canvas, 188 x 158; Stedeliijk Museum.

Madonna on the Sleigh, 1947; oil on canvas, 97 x 80; Stedelijk Museum.

BASLE (SWITZERLAND)
The Cattle Dealer, 1912 oil on canvas, 97 x 200.5; Kunstmusuem

CHICAGO (UNITED STATES)
Birth, 1912; oil on canvas, 112.5 x 193.5; Art Institute of Chicago

White Crucifixion, 1938; oil on canvas, 155 x 140; Art Institute of Chicago.

ESSEN (GERMANY)
Champs de Mars, 1954-55; oil on canvas, 149.5 x 105; Folkwang Museum.

HAMBURG (GERMANY)
Bridges on the Seine, 1954; oil on canvas, 111.5 x 163.5; Kunsthalle.

LONDON (ENGLAND)
Reclining poet, 1915; oil on cardboard, 77x77.5; Tate Gallery.

NEW YORK (UNITED STATES)
Woman with Bouquet, 1910; oil on canvas, 64 x 53.5; H.Serger Collection

I and the Village, 1911; oil on canvas, 191 x 150.5; Museum of Modern Art.

The drinking Soldier, 1911-12; oil on canvas, 109 x 94.5; Solomon R. Guggenheim Museum.

The Green Violinist, 1923-24; oil on canvas, 198 x 108.6; Solomon R. Guggenheim Museum.

Lovers in the Lilacs, 1930; oil on canvas, 128 x 87 ; Richard S. Zeisler Collection.

Cow with Umbrella, 1946; oil on canvas 77.5 x 106; Richard S. Zeisler Collection

Great Circus, 1968; oil on canvas, 170 x 160; Pierre Matisse Gallery.

Great Parade 1979-80; oil on canvas, 119 x 132; Pierre Matisse Gallery.

PARIS (FRANCE)
To Russia, With Asses and Others, 1911-12c; oil on canvas, 156 x 122; Georges Pompidou Centre

Acrobat, 1930; oil on canvas, 65 x 32;Georges Pompidou Centre

The Fall of Icarus, 1975; oil on canvas, 213 x 198; Georges Pompidou Centre.

PHILADELPHIA (UNITED STATES)
To my Fiancé, 1911; gouache, oil and watercolor on paper, 61 x 44.5; Philadelphia Museum of Art.

Poet (Half-past Three), 1911; oil on canvas; 196 x 145; Philadelphia Museum of Art.

Self-portrait with White Collar, 1914; oil on canvas; 30 x 26.5; Philadelphia Museum of Art

The Smolensk Journal, 1914; oil on paper on canvas, 38 x 50.5, Philadelphia Museum of Art

The Water pail, 1925, oil on canvas,; 99.5 x 88.5; Philadelphia Museum of Art

VENICE (ITALY)
The Jew at Prayer (Vitebsk Rabbi), 1914; oil on canvas, 104 x 84; Modern Art Museum

ZURICH (SWITZERLAND)
Russian Wedding, 1909; oil on canvas, 68 x 79; E.G. Buhrle Collection.

Birth, 1910; oil on canvas, 65 x 89.5; Kunsthaus

Window, 1924; oil on canvas, 98 x 72; Kunsthaus.

War, 1964-66; oil on canvas, 163 x 231; Kunsthaus.

BIBLIOGRAFIA

Chagall's self-biography, *My life*, is a useful aid in understanding some events in his life. It was written in Russian between 1921 and 1922 just before the artist left Russia for good. In 1931 the French version, *Ma vie*, prepared by Bella, was published in Paris. Noteworthy are also *Bella's book of memories* Lumières Allumeés, Paris 1973.

1922 T. Däubler, *Marc Chagall,* Roma

1928 W. George, *Marc Chagall,* Paris

1929 P. Fierens, *Marc Chagall,* Paris

1931 R. Schwob, *Chagall et l'âme juive,* Paris

1945 L. Venturi, *Marc Chagall,* New York

1946 J. J. Sweeney, *Marc Chagall,* New York

1948 M. Ayrton, *Chagall,* London

1949 U. Apollonio, *Chagall,* Venezia

1952 W. Erben, *Marc Chagall,* München

1957 W. Schmalenbach, *Chagall,* Milano

1961 M. Brion, *Chagall,* London
F. Meyer, *Marc Chagall,* Köln

1965 J. Cassou, *Marc Chagall,* London

1966 A. Parinaud, *Chagall,* Paris

1972 W. Haftmann, *Marc Chagall,* New York

1979 C. Sorlier, *Chagall by Chagall,* New York
W. Schmalenbach, *Marc Chagall,* Paris

1983 P. Provoyeur, *Chagall, le Message Biblique,* Paris

1986 R. Negri, *Marc Chagall,* Milano

1994 R. F. Walther - Metzger, *Chagall,* Köln

ONE HUNDRED PAINTINGS:

every one a masterpiece

Chagall — The Falling Angel

Dali — The Persistence of Memory

Kandinsky — The First Abstract Watercolour Painting

Leonardo — The Last Supper

Manet — Le déjeuner sur l'herbe

Raphael — School of Athens

Rembrandt — Supper at Emmaus

Renoir — Moulin de la Galette

Rubens — Garden of Love

Van Gogh — Starry Night

The Work of Art. Which one would it be?

...It is of the works that everyone of you has in mind that I will speak of in "One Hundred Paintings". Together we will analyse the works with regard to the history, the technique, and the hidden aspects in order to discover all that is required to create a particular painting and to produce an artist in general.

It is a way of coming to understand the sensibility and personality of the creator and the tastes, inclinations and symbolisms of the age. The task of "One Hundred Paintings" will therefore be to uncover, together with you, these meanings, to resurrect them from oblivion or to decipher them if they are not immediately perceivable. A painting by Raffaello and one by Picasso have different codes of reading determined not only by the personality of each of the two artists but also the belonging to a different society that have left their unmistakable mark on the work of art. Both paintings impact our senses with force. Our eyes are blinded by the light, by the colour, by the beauty of style, by the glancing look of a character or by the serenity of all of this as a whole. The mind asks itself about the motivations that have led to the works' execution and it tries to grasp all the meanings or messages that the work of art contains.

"One Hundred Paintings" will become your personal collection. From every painting that we analyse you will discover aspects that you had ignored but that instead complete to make the work of art a masterpiece.

Federico Zeri

Coming next in the series:

Matisse, Magritte, Titian, Degas, Vermeer, Schiele, Klimt, Poussin, Botticelli, Fussli, Munch, Bocklin, Pontormo, Modigliani, Toulouse-Lautrec, Bosch, Watteau, Arcimboldi, Cezanne, Redon